IMAGES
of America

CRISFIELD

The First Century

D1211222

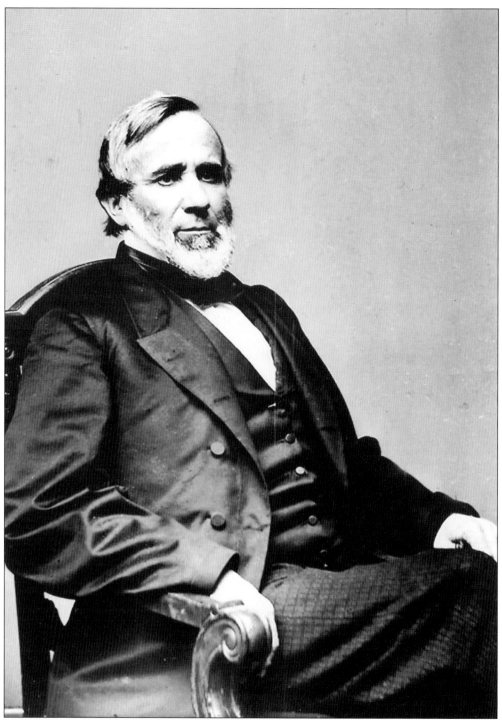

JOHN W. CRISFIELD. Crisfield's namesake, John W. Crisfield (1808–1897), was one of the most powerful men to emerge from Maryland's Eastern Shore. A lawyer, newspaper editor, and congressman, he also served as president of the Eastern Shore Railroad, which was credited with turning Crisfield into the Seafood Capital of the World.

IMAGES
of America

CRISFIELD

The First Century

Jason Rhodes

ARCADIA

Published by Arcadia Publishing
Charleston SC, Chicago IL, Portsmouth NH, San Francisco CA

Printed in the United States of America

Library of Congress Catalog Card Number: 2005935862

For all general information contact Arcadia Publishing at:
Telephone 843-853-2070
Fax 843-853-0044
E-mail sales@arcadiapublishing.com
For customer service and orders:
Toll-Free 1-888-313-2665

Visit us on the Internet at www.arcadiapublishing.com

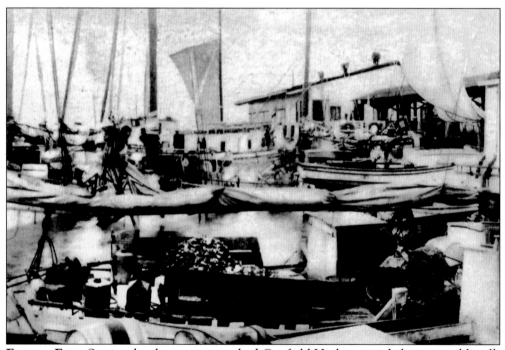

END TO END. Stories that boats once packed Crisfield Harbor so tightly one could walk from one end to the other on their decks are proven true by this photograph, *c.* 1933. In 1910, more boats were registered in Crisfield than anywhere else in the United States.

CONTENTS

ACKNOWLEDGMENTS

Undertaking any project of this size would be impossible without assistance from many individuals dedicated to preserving the history of Crisfield.

The author extends thanks to the following people for their help in making this book a reality: June Christy, Calvin "Cabby" Dize Jr., Mary Elizabeth Drewer, Kenny Evans, Randy Laird, Skip Marshall, Bobbi Jean and Raymond "Tighty" Mister, Mary Nelson, Frank and Harriet Rhodes, George Tawes, and Norris "Scorchy" Tawes. Thanks also to the Mariners Museum of Newport News, Virginia, for providing the cover image.

Pictures for which no credit is given are from the author's collection.

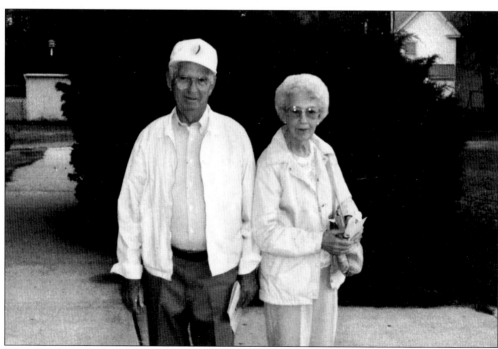

This book is dedicated in memory of the author's grandparents, Miles "Shamrock" (1915–2005) and Lurie (1919–2002) Rhodes, seen here at Crisfield High School in 1995. Both longtime residents of Crisfield, they blessed the author with many stories and descriptions of the area from the early 20th century.

INTRODUCTION

As Maryland's southernmost city, located in Somerset County on the Eastern Shore, Crisfield is a unique place with a history all its own. The area today known as Crisfield is thought to have been first settled like much of the United States by Native Americans, in this case predominately the Annemessex and Pocomoke tribes of the Algonquin Nation. The name Annemessex itself is thought to mean "beautiful waters" or "bountiful waters," both fitting descriptions of the area.

English settlers first came to the area from Virginia in the early 1660s. Some came for the choice land that still could be found outside the Virginia borders. Those not affiliated with the Church of England likely left the Virginia colony for religious reasons. One of the first settlers in the area was Benjamin Summers, for whom 300 acres in lower Somerset County were surveyed on February 10, 1666. He named the land Annemessex after the peaceful Native Americans he found there. Within days, the homestead of Makepeace was surveyed for settler John Roach. Makepeace became the first home built in the Crisfield area.

Within Annemessex, the fishing village of Somers Cove emerged, its name a variation of Benjamin Summers's surname. Farther inland, farming became the profession of choice. In Somers Cove, nearly all worked on the water, catching crabs, fish, and oysters. Many names found in the village then are still seen in the area today, including Sterling, Nelson, Lankford, Cullen, Whittington, Bozman, and Ward.

Shortly after the Civil War, John W. Crisfield, an Eastern Shore native and Somerset County resident with many political connections, sought to expand the Eastern Shore Railroad, of which he was president. He personally signed right-of-way deeds to property throughout the Eastern Shore all the way to the harbor at Somers Cove. With the railroad providing easy shipping, the seafood industry boomed practically overnight. In gratitude, the communities of Annemessex and Somers Cove joined together in 1866 and rechristened themselves in John Crisfield's name.

During the next several decades, Crisfield grew exponentially, not only in commerce and opportunity but also in physical size. It was not uncommon for prospective businessmen to purchase underwater lots with the expectation of building them up with oyster shells and erecting seafood packinghouses to take advantage of the natural abundance of the Chesapeake Bay. Due to this practice, much of Crisfield's current downtown section actually is built atop a bed of oyster shells.

With opportunity came crime and corruption, so much so that by the late 19th century, Crisfield was known as "The Dodge City of the East." Population-wise, it was smaller only than Baltimore City within Maryland's boundaries. In 1872, the city was incorporated, and amenities including paved streets, indoor (or at least on-property) plumbing, and gas and electric services; full-fledged police and fire departments followed.

By the late 19th century, order had come to Crisfield. However, the growth did not stop. By 1910, more boats were registered in Crisfield than any other port in the United States. By the early 1930s, it was known nationally as the "Seafood Capital of the U.S.A." Before World War II, it gained international acclaim as the "Seafood Capital of the World," a slogan the city still uses to market itself today. Unfortunately the prosperity would not last.

In the 1950s, processing and manufacturing began to rival seafood as major industries in the city. Mrs. Paul's Kitchens established a plant in the city to package not only seafood but also foods like sweet potatoes and onion rings. Chas. D. Briddell, Inc., already a top employer, introduced the Carvel Hall cutlery line, which quickly became a household name. The company made knife production seem to many like a better employment option than the sometimes volatile seafood industry. The Rubberset Company, a division of the Sherwin-Williams Company, continued the trend in 1967, opening the world's largest paintbrush manufacturing plant in Crisfield.

By the early 1970s, it was apparent that seafood no longer was the wave of the future for Crisfield. By the late 1980s, it also became apparent there was little future in the city's manufacturing industry. Mrs. Paul's closed in 1988, and Chas. D. Briddell, by then renamed for the Carvel Hall line, followed a little more than a decade later. From the mid-1980s through the early 21st century, the city was in a doldrums from which it seemed it would never escape.

However, in recent years, there has been at least a partial escape. With miles of waterfront property at the tip of the rapidly growing retirement community of the Delmarva Peninsula, Crisfield suddenly drew the interest of condominium developers in 2002. Just as the railroad had done more than a century before, these developers drove up property values in the city beyond anyone's wildest dreams practically overnight. Properties that had been on the market for years in the thousands-of-dollars price range suddenly drew millions. As graders and cranes constructed tall buildings where once millions of oysters were shucked, Crisfield's skyline changed in an instant.

Crisfield: The First Century is dedicated to the spirit that built the city from its founding in 1866 through the end of its reign as a true seafood capital in the mid-1960s. Going beyond seafood, this book takes a look back at the places, events, and people that made Crisfield what it is today. As the city experiences a rebirth, its past lives on through this volume.

One

RAILS TO CRISFIELD

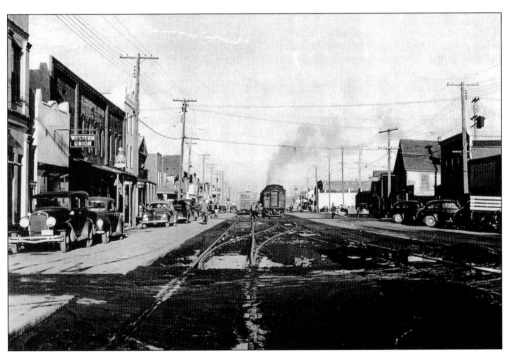

SETTING RECORDS. Seen here *c.* 1927, the railroad helped Crisfield's businesses set many world records for shipping seafood. In December 1920, Crisfield packers shipped an estimated 60,000 gallons of shucked oysters in a single day. In April 1922, they set the world fish shipping record with 29 train carloads in one day. In August 1928, they managed to break two records in one week, shipping 1.5 million soft crabs and an estimated 20,000 gallons of crabmeat.

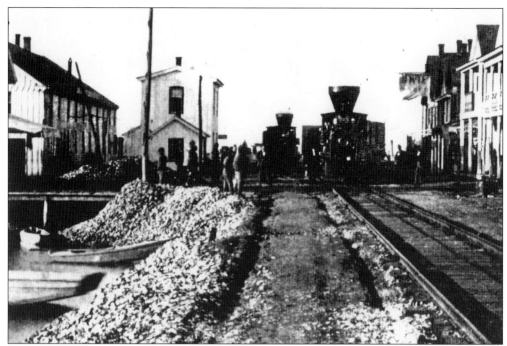

OYSTER SHELLS. Crisfield is a city literally built on oyster shells, as this 1860s stereoscope image shows. It was not uncommon for businessmen in the late 19th and early 20th centuries to buy underwater lots with the intention of building them above sea level using the millions of shells discarded from local packinghouses each month.

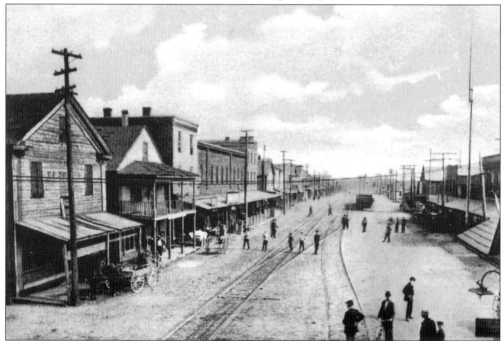

TRACKS IN THE DIRT. The Eastern Shore Railroad arrived long before Crisfield's roads were paved, as evidenced by this late-19th-century image of the tracks on Main Street.

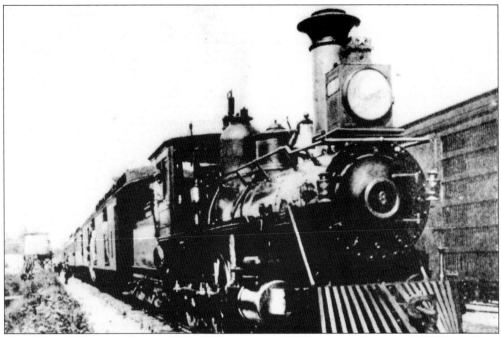

OLD NO. 8. Born in Hopewell in 1852, engineer William Landon ran "Old No. 8," the iron horse to visit Crisfield most frequently throughout the railroad's heyday in the area. Landon joined the Eastern Shore Railroad in 1871 and was celebrated as the oldest engineer employed by its successor, the New York, Pennsylvania, and Norfolk Railroad, in 1917 at age 65.

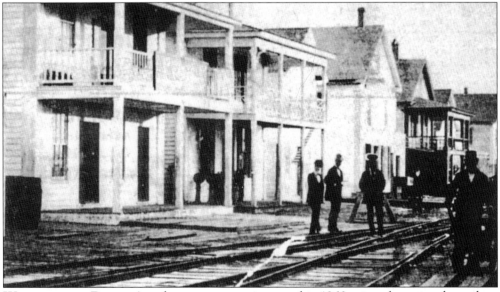

WALKING THE RAILS. Another stereoscope image, this 1860s view shows just how close the trains that rumbled through Crisfield came to local residences and businesses. In the full stereoscopic view, a similar image was paired with this one on a rectangular card. When seen through a stereopticon, a precursor to today's View-Master, the pictures appeared to have three dimensions.

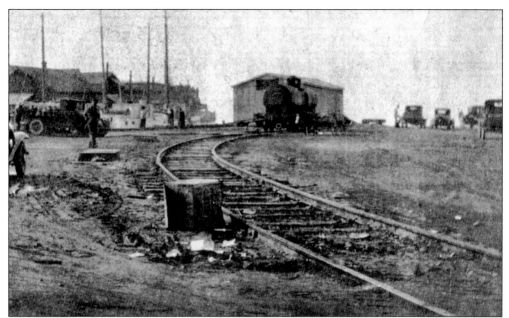

THE SPUR. The spur that led to the Railway Express Agency office near the city's railroad depot and steamboat wharf was one of the least photographed portions of the local railroad infrastructure for reasons obvious in this rare 1920s photograph. While the view was not picturesque, the spur played an important part in getting trains where they needed to go. A close look at this image reveals a vintage Kellogg's Corn Flakes box in the background.

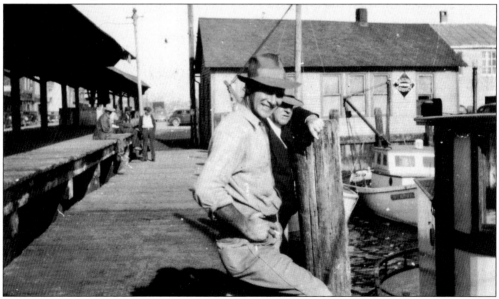

RAILWAY EXPRESS AGENCY. Located at the current site of Captain's Galley Condominiums, Crisfield's Railway Express Agency office is seen here behind Wells Evans (left) and John Marshall in this 1947 view, looking from the city's steamboat wharf. The agency oversaw daily shipments from the area. The boat *Gussie Mae* is docked in the foreground.

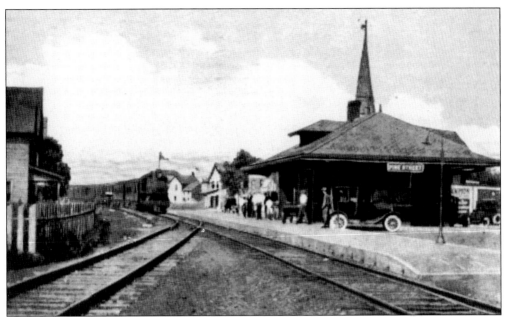

PINE STREET STATION. Crisfield's New York, Pennsylvania, and Norfolk passenger station opened on Pine Street in 1922 following a movement by the citizens of Crisfield and the local newspaper, the *Crisfield Times*, to bring a decent passenger station to the city. The station included a lounge area for railroad personnel, a heated indoor waiting area for passengers, and public restrooms. After outliving its usefulness as a railroad station, the building became commercial property.

WAITING FOR THE TRAIN. Passengers waited on Pine Street Station's outdoor platform when this photograph was taken. Construction on the steeple of Shiloh Methodist Church in the background probably dates the picture to around 1955, when the steeple was rebuilt following destruction caused by Hurricane Hazel.

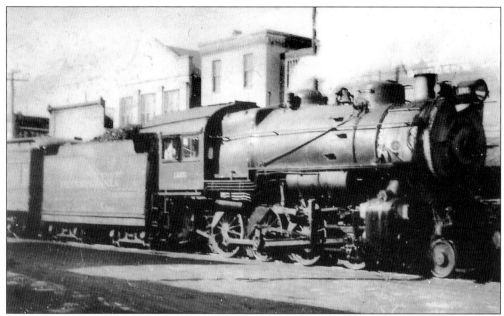

LEAVING CRISFIELD. Heading out of the city, the train passed a number of dwellings and businesses. The railroad serving Crisfield was owned by a number of different companies throughout the years, including the Eastern Shore Railroad; the Baltimore, Chesapeake, and Atlantic Railway Company; the New York, Pennsylvania, and Norfolk Railroad; and the Pennsylvania Railroad.

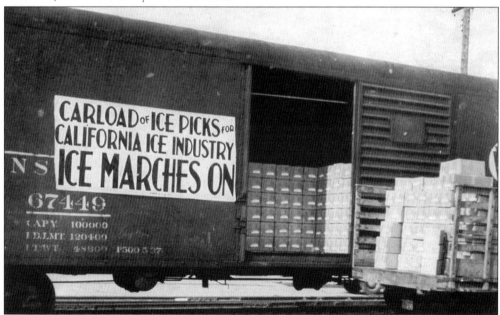

ICE MARCHES ON. While Crisfield's railroad was famous for its seafood shipments, other local businesses made use of the convenience as well. In this 1940s photograph, a carload of ice tools prepared to make its way from the Chas. D. Briddell, Inc., Main Street plant to California. Following World War II, Briddell was one of the world's leading manufacturers of ice picks and shavers among other fabricated metal items.

Two

SEAFOOD CAPITAL
OF THE WORLD

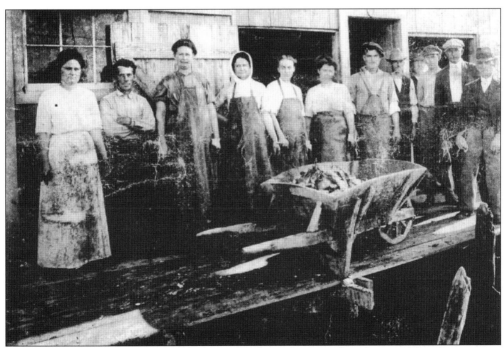

BEGINNING OF THE 20TH CENTURY. Workers from packinghouses like this one, *c.* 1900, were instrumental in building Crisfield into the Seafood Capital of the U.S.A, a nickname celebrated with a commemorative postmark in 1936. By the end of that decade, shipments had grown so large that the slogan expanded to "Seafood Capital of the World," a nickname still used to promote the city today.

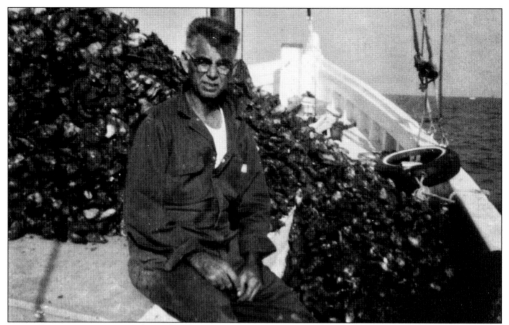

BUY BOATS. Capt. Miles Rhodes was surrounded by the day's purchase aboard the buy boat C. A. *Christy* when this 1960s photograph was taken. For decades, Crisfield's seafood processors sent buy boats into the waters of the Chesapeake Bay to purchase fish, crabs, and oysters fresh from the decks of watermen's vessels. In 2005, Rhodes and fellow-captain Maurice Tull became the first buy boat operators honored by the Watermen's Hall of Fame.

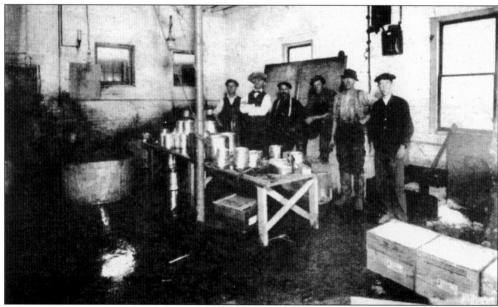

OYSTER BUCKETS. Oysters shucked commercially were traditionally transferred from shuckers' stalls to the buckets seen on the table in this photograph of the John T. Handy Company around 1903. Shuckers were paid by the bucket, often with tokens inscribed "1 bkt," which could be redeemed for cash at the end of the week.

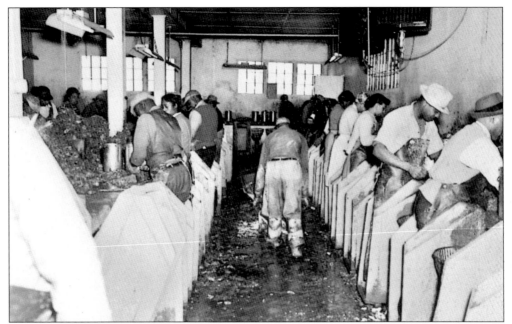

SHUCKING ROOM. Stalls lined the shucking room of Geo. A. Christy and Son Seafood, c. 1955, as the employee in the middle delivers wheelbarrows full of unshucked oysters to the shuckers' stalls. Oyster buckets are visible on the table against the back wall and in front of the pillar to the left. (Courtesy June Christy.)

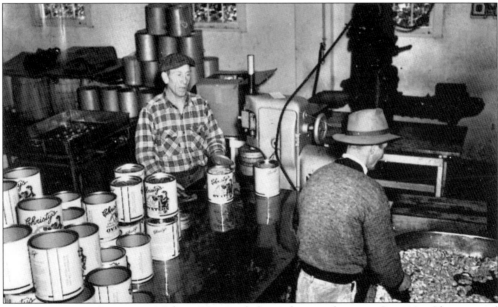

BLOWING THE OYSTERS. Melvin Harris, left, and an unknown Geo. A. Christy and Son employee blow a vat of shucked oysters to separate bits of shell and grit from the mollusks as part of the pasteurization process in this image, c. 1955. The Christy's cans used to package the oysters are known by some collectors today as the "Elvis can" because the sailor on the label bears a resemblance to singer Elvis Presley. (Courtesy June Christy.)

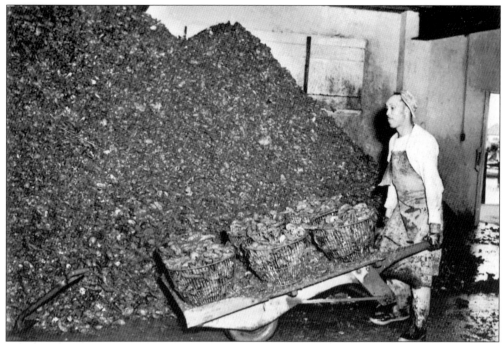

DISCARDING SHELLS. Discarded shells were natural byproducts of the oyster industry. Oyster-shell piles, like this one at Geo. A. Christy and Sons around 1955, were common at processing plants throughout the city. (Courtesy June Christy.)

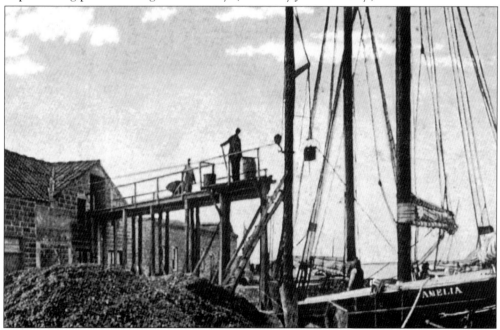

USEFUL PURPOSE. The boat *Amelia* is seen in this 1890s view as seafood workers add more shells to an outdoor pile. The discarded shells did not go to waste. For decades, Crisfield's lime plant ground oyster shells from many of the city's seafood processors into lime fertilizer to be used in Somerset County's other major industry, farming.

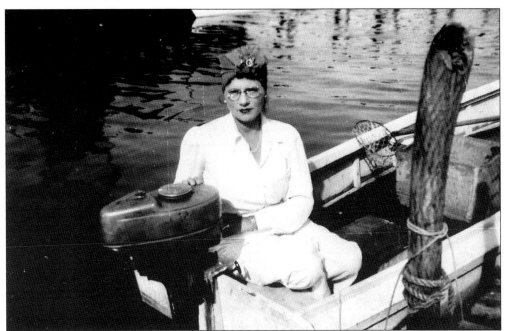

CRABBIN' ANNIE. As a woman in a man's world, Annie Parkinson broke the gender barrier among watermen by becoming the area's (and possibly the world's) first commercial waterwoman. Born in Deal Island about 1900, she moved to Crisfield with her five children in 1929. One of the most noted figures in the 20th century seafood industry, she quickly earned the respect of her peers, along with the nickname "Crabbin' Annie," a moniker she retained until her death in 1957. (Courtesy Patsy Somers.)

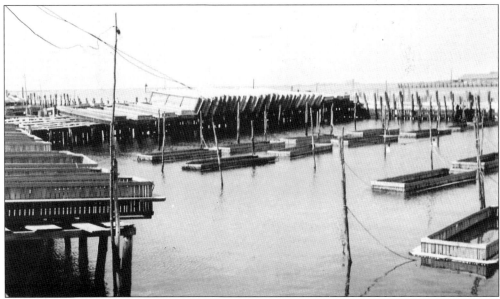

CRAB POUNDS. Once crabs were caught, they often were placed into complexes like this, known as a crab pound, where they were allowed to shed their outer shells and become soft crabs. The crustaceans would then be "fished up" with a net and delivered to seafood processing plants.

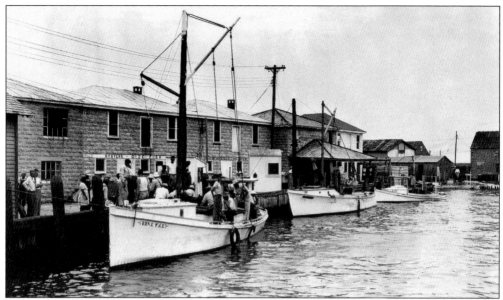

PACKINGHOUSES. The crew of the *Edna Mae* unloads the day's crab catch alongside Dize Seafood in this July 1945 image. Farther down, similar boats dock outside Hickman and Sterling Oyster Packers for similar purposes. While the number of crab pickers Hickman and Sterling employed is unknown, the company is believed to have employed some 2,000 oyster shuckers during its earliest years, starting in 1905. (Courtesy the Mariners Museum.)

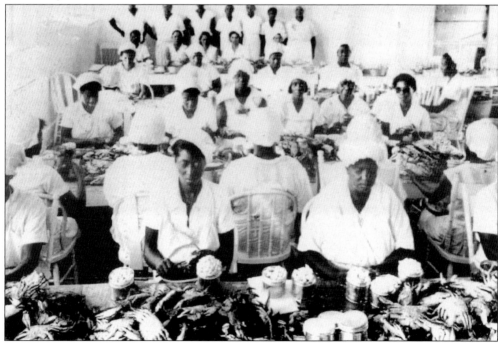

PICKING CRABS. Crab pickers packed the workroom of N. R. Dryden Seafood when this 1930s photograph was taken. In a vocation still practiced in the 21st century, the best pickers can pick 12 pounds of crabmeat or more per hour.

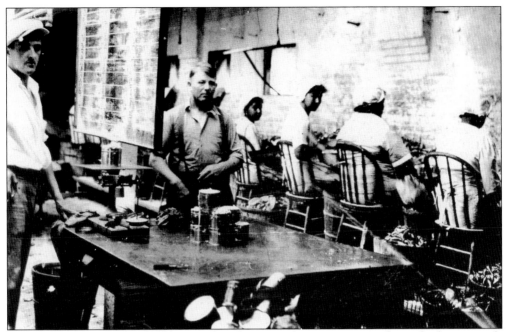

CANNING CRABMEAT. Today, as it has for more than a century, the picked meat ends up in cans, such as the ones seen in this early-20th-century view. The cans are then sealed and shipped to retailers and restaurants for public consumption.

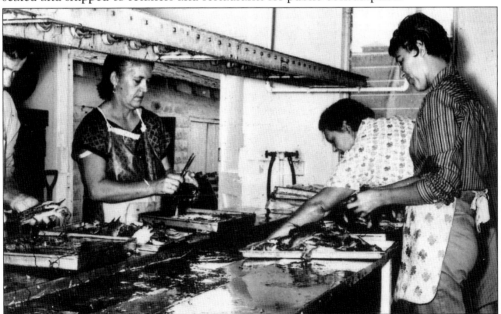

SOFT CRABS. Geo. A. Christy and Son employees cleaned soft crabs when this photograph was taken c. 1960. The world's soft crab industry began in Crisfield prior to the Civil War but was not popularized until the 1870s. By the early 20th century, they were one of the most popular seafood dishes throughout the East Coast. Today soft crabs are popular worldwide. Pictured from left to right are Herman Cater, Frannie Jones, Madelyn Bradshaw, and Marynell Hinman.

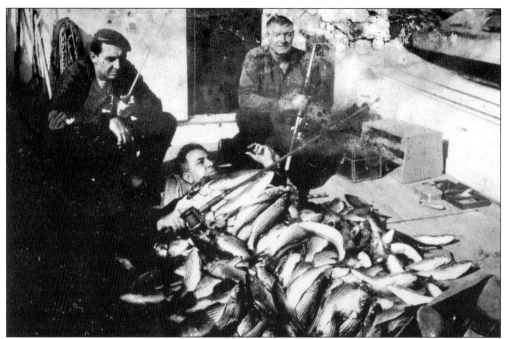

A GOOD DAY'S CATCH. From left to right, Addison Nelson, Shug Dryden, and Capt. Bill Thomas show off their catch aboard Thomas's boat, *Lucky Lady, c.* 1950. While often falling behind oysters and crabs in the popularity of Crisfield seafood, the fishing industry once was an important component in the area's economy.

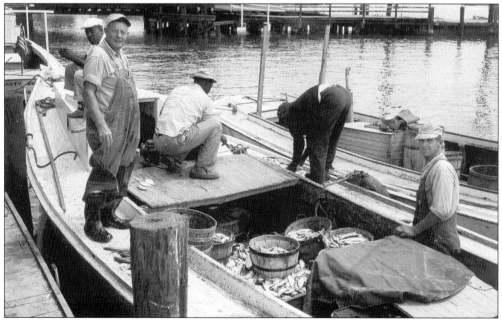

UNLOADING FISH. Watermen unload fish near the Jersey Island Drawbridge in this 1960 photograph, which includes fishermen Wyatt Pruitt, left, and Peter Crockett, both of Tangier Island, Virginia. Species caught commercially in Tangier Sound between Crisfield and Tangier included shad, croakers, trout, and menhaden.

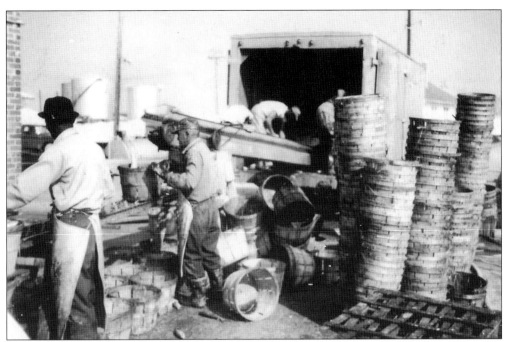

UNLOADING THE TRUCK. In later years, fish was transported to packinghouses via truck rather than boat, as this 1960s view of Geo. A. Christy and Son Seafood shows.

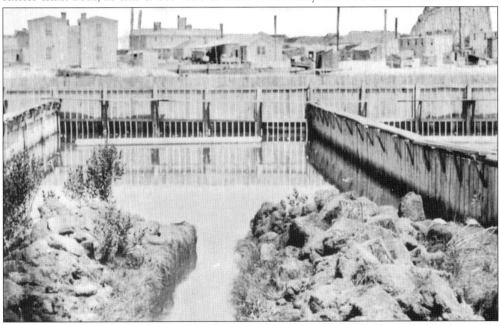

TERRAPIN POUND. The diamondback terrapin industry was the brainchild of a single Philadelphia businessman, Albert LaVallette Jr. In 1887, he moved to Crisfield and offered to purchase terrapin from local watermen, who often found their abundance an annoyance while harvesting more lucrative items such as oysters, crabs, and fish. LaVallette grew the terrapin, feeding them crab and fish byproducts obtained from local processors, in this pound adjacent to where Somers Cove Marina sits today.

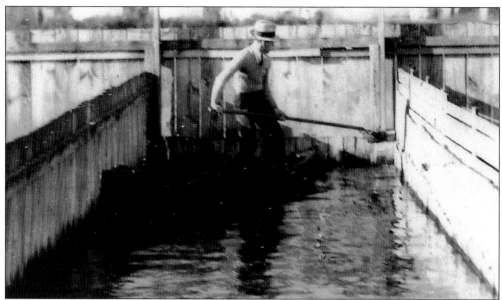

FISHING UP. Marketing the new product that no one had commercialized yet, LaVallette turned the terrapin into a delicacy, granting his supply to only select restaurants in the East Coast's largest cities. Demand skyrocketed, and LaVallette became one of the area's wealthiest seafood barons. Overfishing killed the national terrapin industry in 1912, though a small niche market still existed locally when this unidentified man traversed the pound to fish up terrapin in the 1930s.

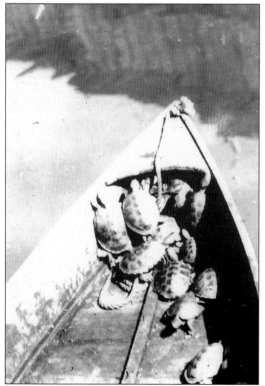

HARVESTED TERRAPIN. The terrapin were transported out of the pound by boat until the last harvest in the 1950s. In 2002, the species came full circle in Crisfield when Maryland's first terrapin sanctuary was established at Janes Island State Park.

Three

BOATS OF
TANGIER SOUND

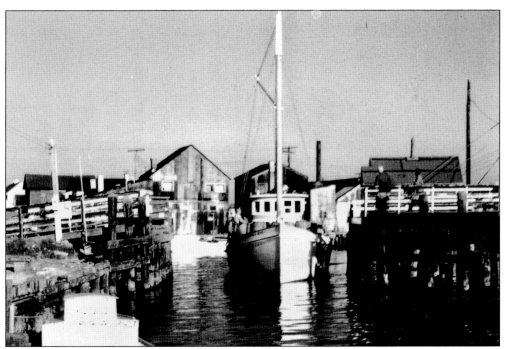

VIRGINIA MAE. Coming through the Jersey Island Drawbridge in 1956, the *Virginia Mae* was one of many boats that traversed Tangier Sound throughout the decades. (Courtesy Scorchy Tawes.)

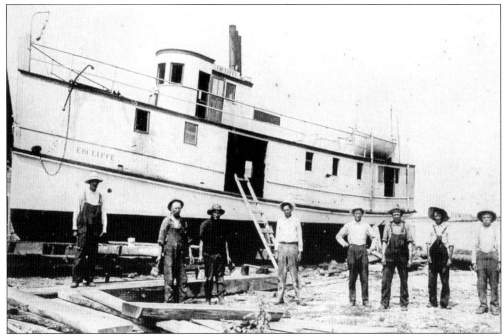

ERCLIFFE. Built in the early 1900s, the *Ercliffe* came to the Crisfield marine railway for a major overhaul that allowed its crew to better compete with the newer, sleeker boats that sailed the Chesapeake Bay in later years.

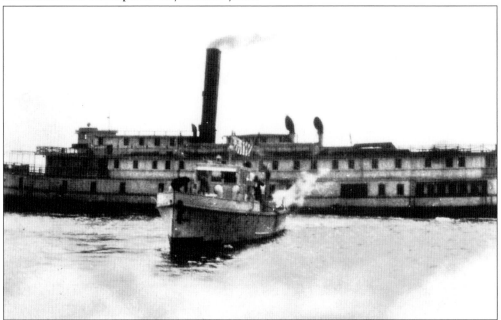

PIANKATANK. Steamships like the *Piankatank*, seen here in 1936, provided daily passage from Crisfield to Baltimore for nearly a century, from the city's founding to the mid-20th century. Better roads and automobiles sounded the death toll for these steamers, making passage by land less expensive than the costly ships could offer. In front of the *Piankatank* is the U.S. Coast Guard cutter *Travis*.

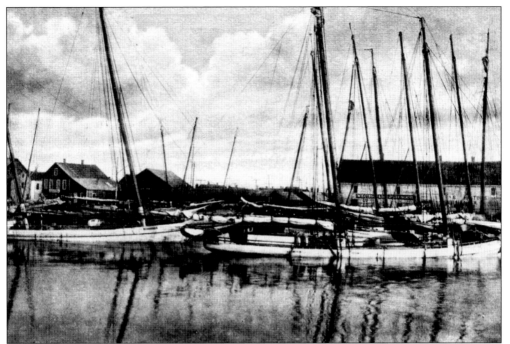

VARIETY OF BOATS. Skipjacks, bug eyes, and bateaux were a staple in Crisfield Harbor from the late 19th century through the mid-20th century.

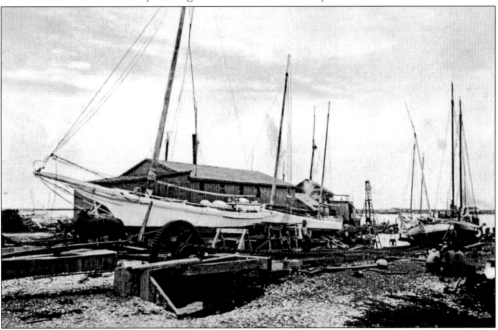

NELSON'S MARINE RAILWAY. John "Bun" Nelson operated this railway for boat repair on the future site of Geo. A. Christy and Son Seafood. Horses powered the gears that moved the railway when this photograph was taken in 1904. Later motors did away with the need for animal labor at the business. The boat seen here on the railway is an unidentified skipjack, one of the most unique vessels on the Chesapeake Bay.

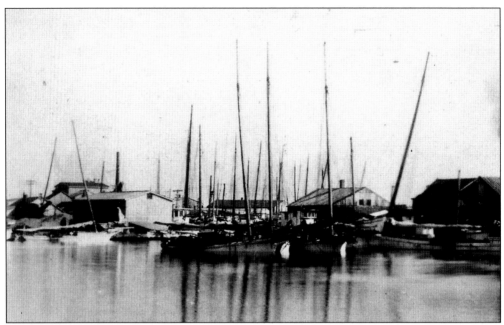

OYSTER FLEET. Crisfield's oyster fleet could not reach its harvest when this photograph was taken in early 1936. One of the worst freeze-ups in the history of Tangier Sound kept most boats off the water for more than two weeks that year.

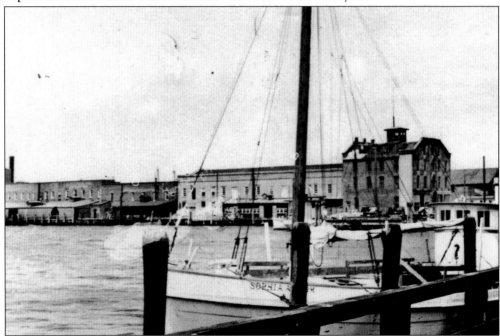

CUSTOMS HOUSE. Crisfield's former customs house is seen at the right in this 1930s image taken from the city's steamboat wharf. In 1933, the customs house moved to the current Crisfield Post Office, where it remained until being discontinued in 1971. The boat *Sophia A. Duram*, seen here in the foreground, was a converted bug eye with lanyards and deadeyes holding its riggings in place instead of the more traditional turnbuckles.

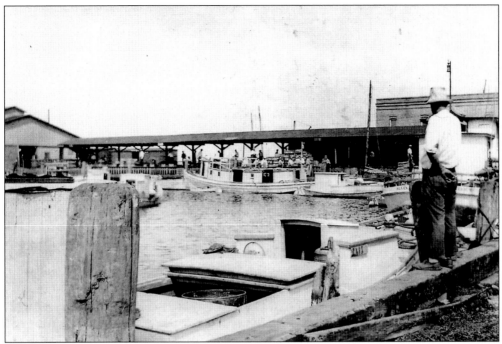

WORKBOATS. Crabbing boats and buy boats are tied up at the city's steamboat wharf and surrounding seafood businesses in this view, *c.* 1940.

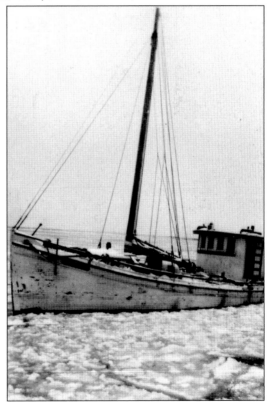

DEWEY. The *Dewey* cuts through the ice as it leaves Crisfield Harbor in this *c.* 1940 image.

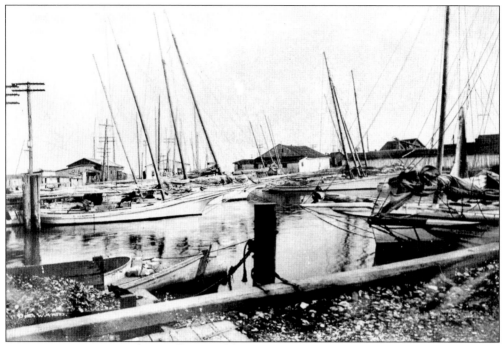

CRISFIELD HARBOR. These tall-masted boats were the norm in Crisfield Harbor when this photograph was taken around 1920.

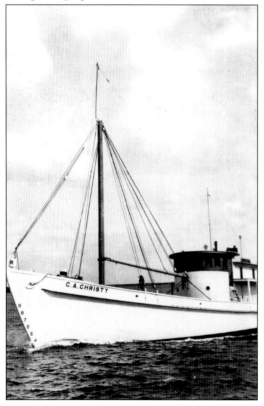

C. A. CHRISTY. One of several buy boats operated by Geo. A. Christy and Son Seafood, the C. A. *Christy* was named for Clarence Christy, the son in the company's name. Clarence joined his father, George, as a partner in the plant in 1910, 20 years after its founding on Tenth Street in 1890. In 1937, five years after George's death in 1932, Clarence's son, Richard, became the third Christy to be granted a partnership in the business.

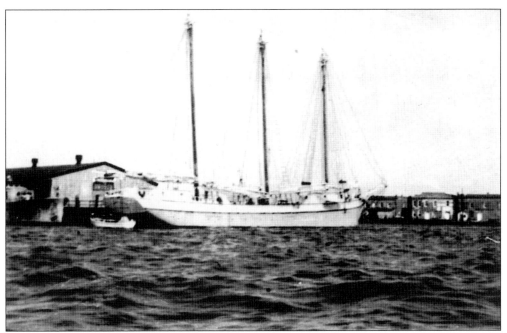

EDWIN AND MAUDE. Built in Bethel, Maryland, and based on the Lower Eastern Shore, this boat has a rich history. Seen here in Crisfield Harbor in 1948, the ship variously served as a commercial fishing vessel and freight boat before becoming a vessel for historic tours on Maine's Penobscot Bay in 1990. Today renamed *Victory Chimes*, it is the largest passenger sailing ship under the U.S. flag and was chosen to appear on the Maine state quarter in 2003.

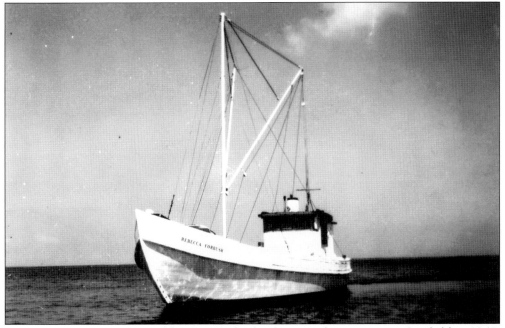

REBECCA FORBUSH. Owned by Gus Forbush, this vessel is seen near Crisfield *c.* 1960. The boat was built in Reedville, Virginia.

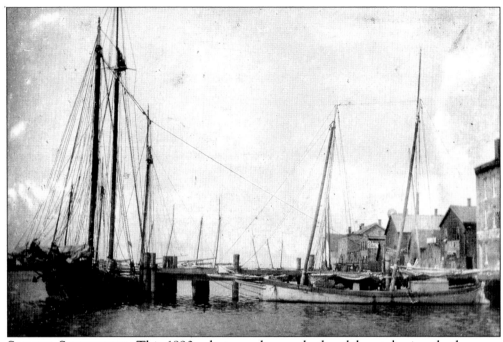

Sailing Schooners. This 1890s photograph reveals the elaborately rigged schooners that called Crisfield home during the late 19th century. The buildings to the right represent ship chandleries, sail makers, marine supply shops, and other maritime businesses essential to Crisfield's survival.

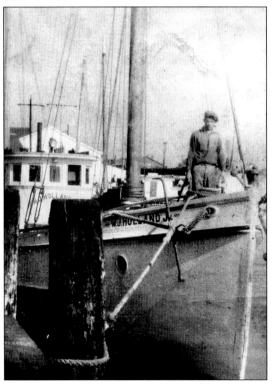

W. J. Holland Jr. The buy boat *W. J. Holland Jr.* is moored in Crisfield Harbor in this view, *c.* 1940. The pilot houses of buy boats sometimes were raised to allow the vessels to haul more cargo.

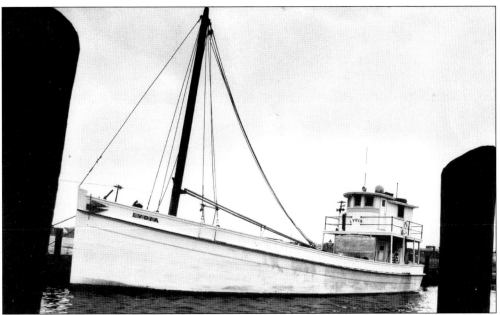

LYDIA. Owned by Capt. Morris "Looney" Ward, the *Lydia* is framed by two pylons in this 1960s photograph. Boats like this were instrumental in Crisfield's seafood industry, allowing watermen to harvest crabs, fish, and oysters. They also sometimes hauled local produce and other freight.

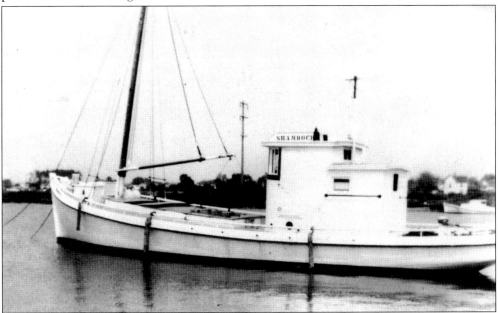

SHAMROCK. Purchased by Capt. Miles Rhodes following World War II and operated as a cargo ship, the *Shamrock* was an 1880s eight-log canoe rebuilt into the form seen here about 1925. Rhodes once said he retained the name from its previous owner because it was cheaper than having the sign repainted. He abandoned the boat in the mid-1970s. Seen here in Apes Hole Creek just outside Crisfield during its sailing days, the *Shamrock's* remains are still visible at the foot of the Jenkins Creek Bridge during low tide.

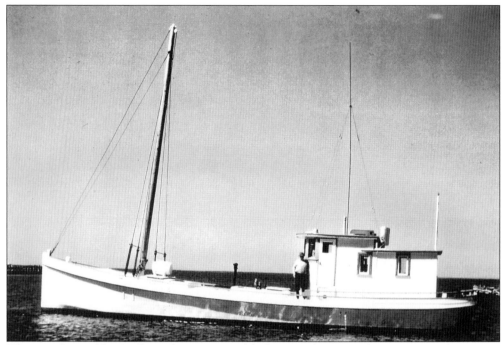

WANDA. Owned by Wells and Vernon Todd, the *Wanda* is seen here in 1955. (Courtesy Scorchy Tawes.)

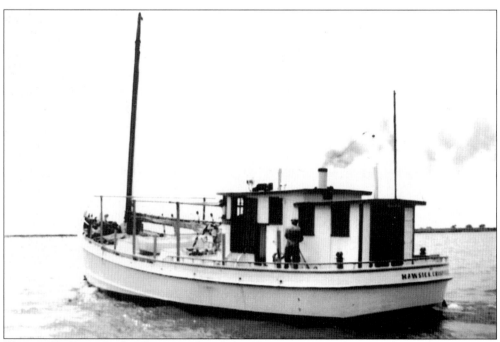

HAWSIE B. Capt. Rudy Thomas piloted the *Hawsie B.*, seen here in the 1960s.

Four

LANDMARKS

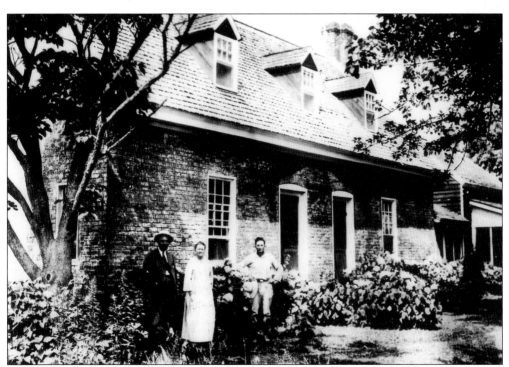

MAKEPEACE. Built by settler John Roach on a parcel of land patented in 1666, Makepeace was one of the first homes built in the Crisfield area. Though the local Native Americans were said to be peaceful, a peace agreement quickly was reached at Makepeace following the death of a white settler allegedly at the hand of a Native American, giving the brick mansion its name. Pictured in this 1920s photograph are, from left to right, unidentified, Mary Sterling, and Edmund "Bluebird" Sterling. (Courtesy Randy Laird.)

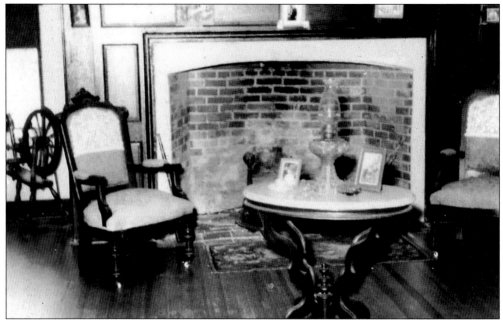

INSIDE MAKEPEACE. For many years, the interior of Makepeace's original section retained its historic furnishings. Besides the traditional features seen in this photograph, the home included rope-net beds and ashtrays made from terrapin shells. Makepeace still stands on Johnson Creek Road just outside Crisfield; today it is a private residence.

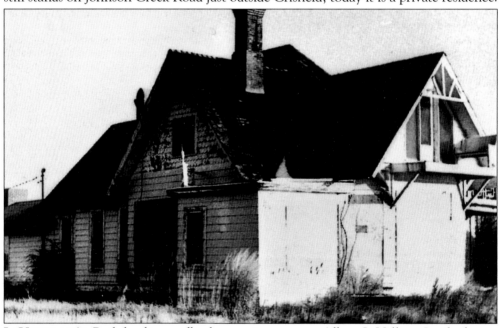

LAVALLETTE'S. Built by diamondback terrapin magnate Albert LaVallette Jr., the house that became synonymous with his name is the only structure that remains in the marshy area adjacent to the terrapin pound, bordered today by the Hammock Point community. Hurricane Hazel washed away much of the land that once led to Crisfield's LaVallette section in 1954. The house remains on private property today.

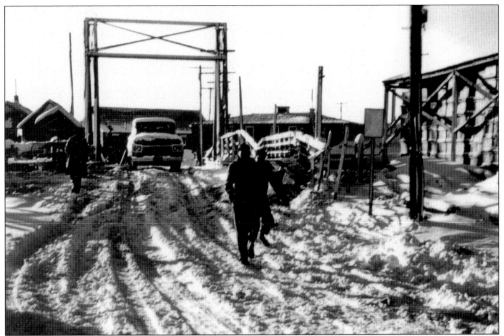

WALKING ACROSS THE JERSEY ISLAND DRAWBRIDGE. One of the most unique drawbridges ever built, the Jersey Island Drawbridge connected the mainland of Crisfield to Jersey Island, which contained the bulk of the area's seafood processing plants. Built in 1880, the bridge consisted of two sections, one of which rolled back across the other to allow ships to pass. (Courtesy Scorchy Tawes.)

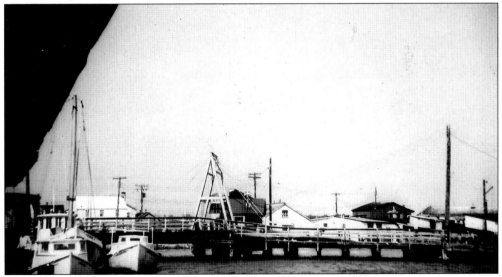

JERSEY ISLAND DRAWBRIDGE. State officials demolished the bridge January 12, 1961, in preparation to widen the waterway to create an entrance for the proposed Somers Cove Marina. Nearly two decades prior, in the 1940s, a Geo. A. Christy and Son Seafood truck unintentionally did part of the job itself, falling through the bridge and bringing to light the dire need for repairs to the structure. The bridge was recognized as a Maryland landmark through the 1950s.

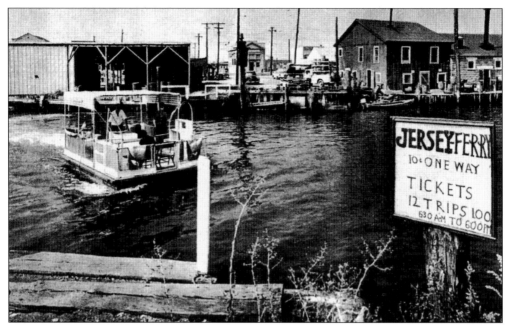

JERSEY BELLE. Though short-lived, the *Jersey Belle* ferry became a symbol of change for Crisfield in the early 1960s. At 10¢ a ride, the vessel transported seafood workers 60 feet from the mainland to Jersey Island for several years. Operated by Ronald Lee Thomas, the ferry operated from 6:30 a.m. to 6 p.m. weekdays. The 1960s marked the beginning of Crisfield's transition from the city that seafood built to a maritime tourism destination.

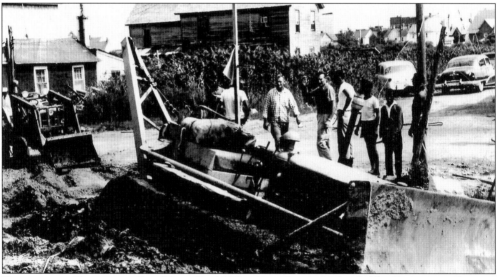

BREAKING GROUND. On May 3, 1960, the City of Crisfield, Somerset County Commissioners, and the Maryland Port Authority entered into an agreement to build Somers Cove Marina. The facility's construction, seen in this 1961 image, paved the way for a grand opening ceremony featuring a crab feast, fireworks, and the U.S. Naval Academy Band on June 16, 1962. The first slip was rented three weeks earlier, on May 23. (Photograph by John McIntosh.)

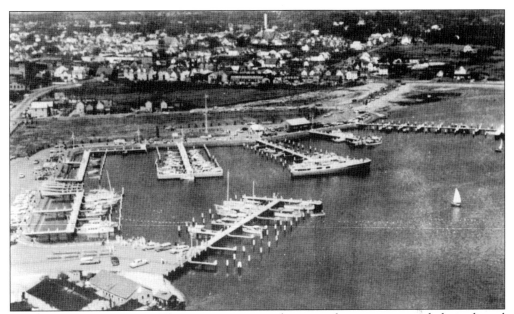

SOMERS COVE MARINA. The city, county, and port authority continued their shared management of the marina until 1983, when all three agencies agreed to turn over operations to the Maryland Department of Natural Resources (DNR). Today the marina is the site of many annual festivals, including the National Hard Crab Derby, J. Millard Tawes Crab and Clam Bake, and Tawes Oyster and Bull Roast.

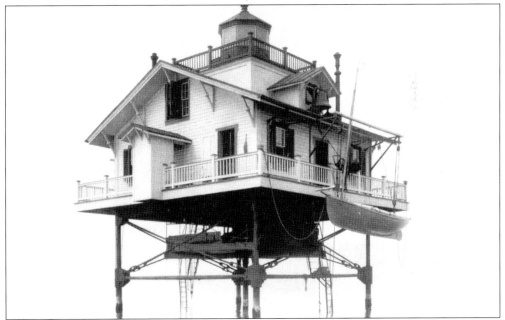

SOMERS COVE LIGHTHOUSE. Built in 1867 at a cost of $10,000, this screwpile lighthouse showed the way into Crisfield and the Annemessex River for many sailors on Tangier Sound. Though the wooden structure was dismantled in 1932—17 years after this photograph was taken in 1915—its framework, with the addition of an automated light, remains a marker for local watermen, who have nicknamed it the "skeleton light."

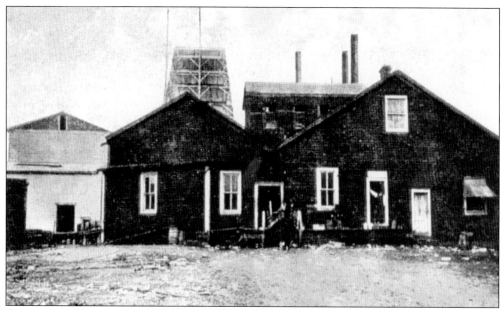

CONSUMERS ICE PLANT. Built in 1872, Crisfield's first ice plant provided ice for many of the local seafood packing companies as well as generating electricity for the city's streetlights. Before equipment existed that could produce ice locally, large quantities were imported from Maine and stored in the plant's cool climate. The plant had a 12-ton capacity. The building was sold to Geo. A. Christy and Son and converted into a seafood processing plant in 1929.

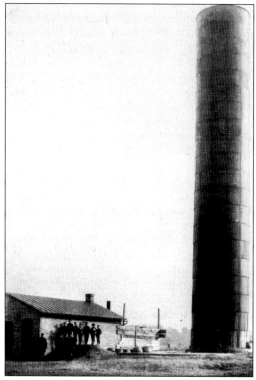

STANDPIPE. Seen here under construction, the standpipe on Somerset Avenue served as Crisfield's main public water source from 1900 until 1983. Championed by town commissioners L. E. P. Dennis and Bunk Riggin, the standpipe replaced the city's first public water supply, which was pumped by a windmill (later a steam engine) at Kennerly's Wharf, near what is now West Main Street. The standpipe system gave Crisfield its first indoor plumbing. It was demolished in 1988.

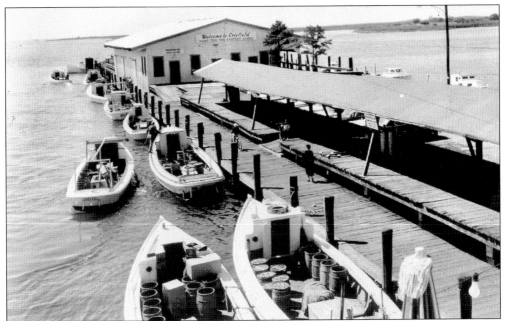

STEAMBOAT WHARF. Small workboats lined the docks of Crisfield's steamboat wharf when this photograph was taken c. 1950. From the city's beginnings, the wharf served as a docking area for commercial and passenger steamboats as well as a railroad depot for trains shipping seafood from the area. In 1960, the City of Crisfield purchased the wharf from the Pennsylvania Railroad to form the Crisfield City Dock, which remains today at the end of West Main Street. (Photograph by John McIntosh, courtesy Mary Nelson.)

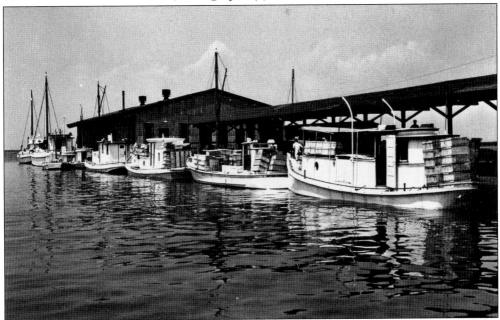

MAIL BOATS. For decades, Crisfield has been the mainland postal terminal for Smith Island, Maryland. The mail boats, seen here c. 1950, line up daily at the Crisfield City Dock and carry the mail to its final destination.

SMALL BOAT HARBOR. Located in Crisfield's Brick Kiln section, the Small Boat Harbor has served as a docking point for many of Crisfield's smaller workboats for decades.

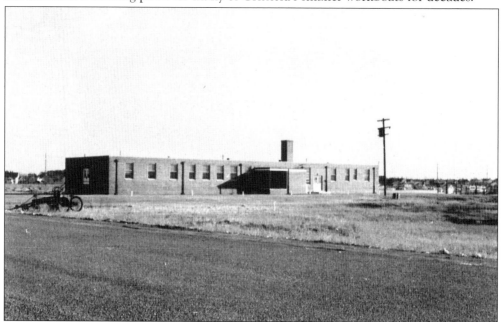

SEAFOOD LABORATORY. In 1954, the University of Maryland established a seafood processing laboratory in Crisfield's Brick Kiln section to determine methods for helping Maryland's seafood packers comply with pure food and drug laws and develop new ways of processing seafood byproducts formerly thought to have no commercial use. The lab was closed in the early 1980s and deeded to the City of Crisfield. In 2003, the building was demolished to make way for residential housing.

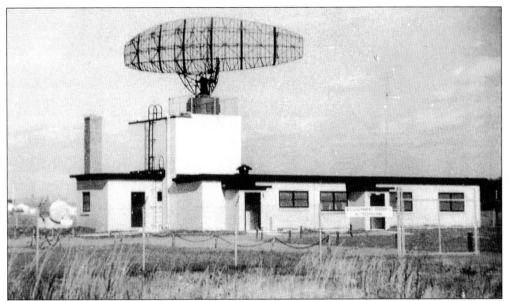

RADAR STATION. The U.S. government built this radar station at Brick Kiln around 1950 to monitor the area for enemy aircraft and missiles. Its radar system was removed in the 1960s, and the building became the Sarah M. Peyton School for special education students in 1964. Once the school moved to Marion Station in the 1990s, the building became the Crisfield Maintaining the Aged in the Community (MAC) Center, which it remains in 2006.

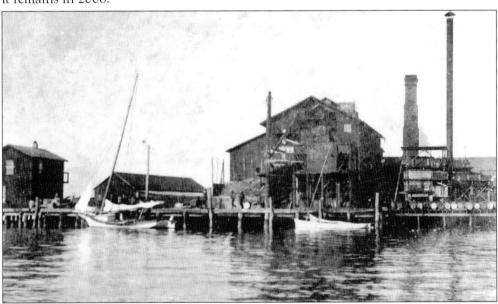

L. E. P. DENNIS AND SON. Built in 1871, the L. E. P. Dennis and Son menhaden fertilizer factory on Old Island, seen here *c.* 1900, was a Crisfield landmark for decades. Dennis operated the company with business partner R. H. Milligan until 1892, at which time Dennis became sole owner of the factory. A community of Dennis's employees thrived on the island until menhaden fishing was outlawed in Maryland in 1908. At that time, Dennis moved his operation to Eastern Shore Virginia. (Courtesy Scorchy Tawes.)

OLD ISLAND. When the U.S. Army took over L. E. P. Dennis's menhaden fertilizer operation in Virginia in 1917 to aid the effort for World War I, Dennis returned to his Old Island plant, which continued operation until 1929. A fire destroyed the abandoned plant in 1932, paving the way for Old Island's popularity as a beach resort, as demonstrated by Raydie James Sterling in this 1960 photograph. (Courtesy Scorchy Tawes.)

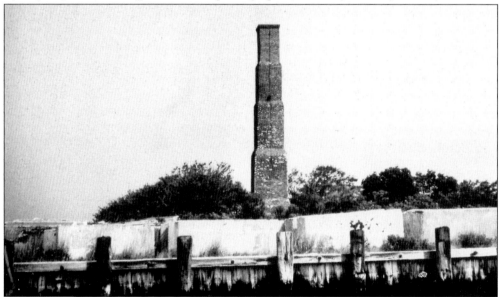

OLD ISLAND CHIMNEY. While most of the L. E. P. Dennis plant was demolished in the 1932 fire, its chimney remained and has served as a nautical marker for those entering Crisfield Harbor ever since. This 1950s photograph shows a row of vaults to be sunk off the island's coast to inhibit erosion of the sandy beach; however, the plan to sink the vaults never came to fruition. In 1962, the island became part of Janes Island State Park.

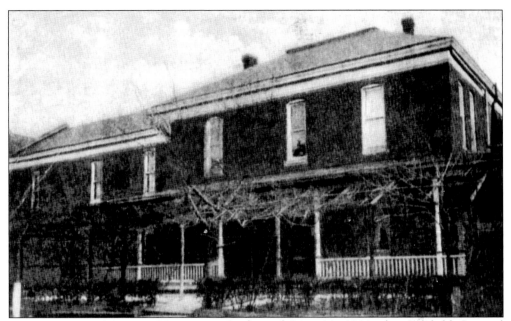

GENERAL AND MARINE HOSPITAL. Dedicated June 30, 1909, the Crisfield General and Marine Hospital was located in an 1898 brick building at Main and Sixth Streets that formerly housed Oliver Gibson's store. Though funding to pay off the debts for the interior construction was difficult to come by, local residents chipped in, and the 26-bed hospital officially opened in 1910.

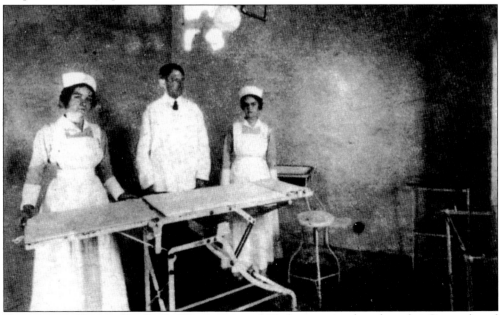

OPERATING ROOM. Dr. R. R. Norris, one of 10 doctors employed at the General and Marine Hospital, stood behind the operating room table in this photograph, c. 1910. The hospital also employed 10 nurses and had the capacity to hold up to 40 beds if necessary. The facility served the area until 1923, when it was replaced by Edward W. McCready Memorial Hospital.

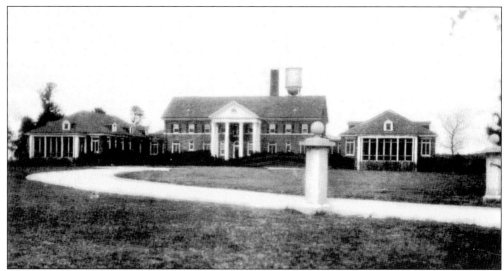

EDWARD W. MCCREADY MEMORIAL HOSPITAL. On September 13, 1919, Crisfield native and wealthy cork industrialist Edward W. McCready; his eight-year-old daughter, Suzanne; and Suzanne's nurse, Margaret Steinbeck, were killed in an automobile-train collision in Westover en route to their home in Chicago. While doctors at the General and Marine Hospital were unable to save them, McCready's wife, Caroline, vowed to repay their kindness. She did so by building a new $200,000 hospital in her husband's memory, dedicated in May 1923 on Hall Highway.

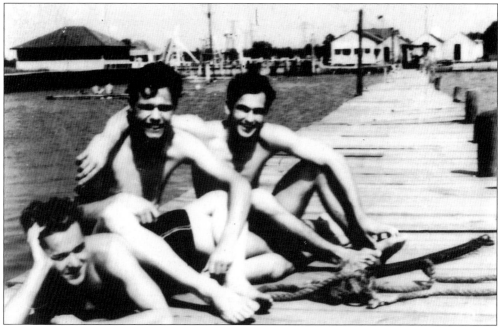

HYGEIA BEACH. Located on Hall Highway at the current site of Miramir, the former home of Gov. J. Millard Tawes, Hygeia Beach was a popular recreational spot for locals through World War II. One of its biggest draws, besides sand and surf, was the Miss Hygeia Beach Pageant, a predecessor to today's Miss Crustacean Pageant. Pictured from left to right at Hygeia are Sid Landon, George Massey, and Gene Sterling.

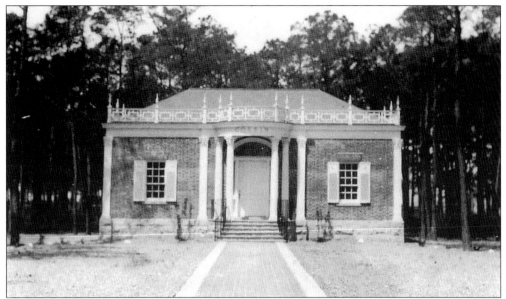

CORBIN MAUSOLEUM. Born into poverty on Old Island on March 6, 1882, Lilyan Stratton Corbin moved to New York in 1898, where she was befriended by a banker who left her a small fortune upon his death in 1904. Later she became a successful actress and author. Following her death in a New Jersey car accident in 1928, she was laid to rest in a mausoleum built for her at the site of the current Carter G. Woodson Elementary School.

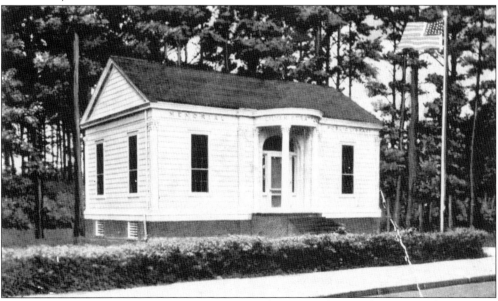

LILYAN STRATTON CORBIN LIBRARY. Break-ins at the Corbin Mausoleum were common due to false rumors that Corbin had been buried with much of her wealth. In 1934, her ashes were moved to the Corbin Library on Main Street Extended, which her husband, Alfred, had proposed in his wife's memory after her death. Dedicated in 1930 and still in use today, the library was Crisfield's second permanent library, replacing the first, founded by city officials at a formerly private residence on Main Street in 1923.

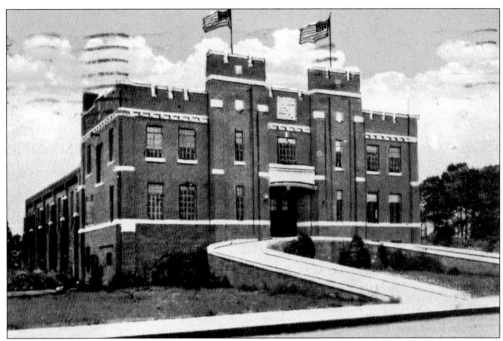

CRISFIELD ARMORY. Built in 1926, the Crisfield Armory was the home of Company L, the city's first Maryland Army National Guard unit, founded in 1914. The unit was reorganized several times, including into Company A in 1946 and into the 1229th Transportation Company in 1968. The armory was renamed in honor of Crisfield native and guard member Gen. Maurice "Dana" Tawes in 1983. In the early 1990s, the 121st Mechanized Combat Engineers occupied the armory. The 1229th returned several years later, serving Crisfield until the unit's relocation to Baltimore in 2005.

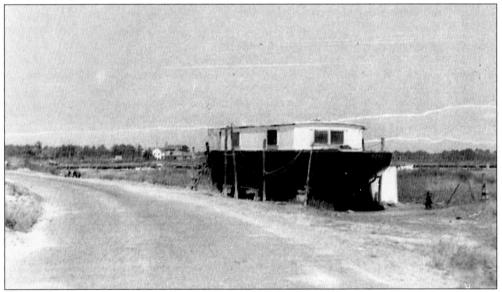

JACK TYLER'S HOUSEBOAT. Located at the foot of the Arch Bridge at Jenkins Creek, this was a familiar sight to those traversing Crisfield's Down Neck area in the mid-20th century. Tyler was one of Crisfield's many watermen of that era.

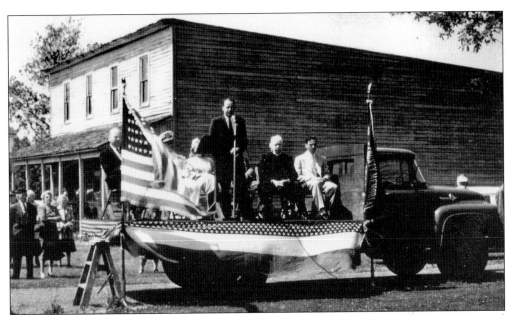

DECORATION DAY SERVICE. Each Decoration Day (now better known as Memorial Day), Crisfield residents turn out in droves to the Crisfield Veterans Cemetery to pay homage to those who gave the ultimate sacrifice for their country. Lum Sterling's dry goods store is seen in the background of this 1956 view. Pictured on the truck are, from left to right, Wade Ward, unidentified, Lil Holland, master of ceremonies Harry T. Phoebus, the Rev. Donald McDonald, and unidentified.

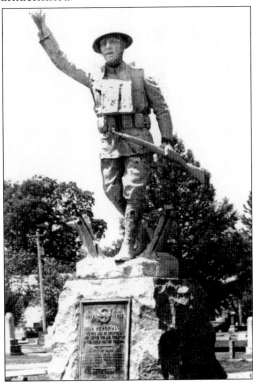

SPIRIT OF THE AMERICAN DOUGHBOY. This original Ernest Moore Viquesney statue, purchased for $2,500 by Stanley Cochrane American Legion Post 16, was unveiled at the Crisfield Veterans Cemetery during Decoration Day 1922. The plaque on the statue's six-foot granite base is inscribed with the names of the nine Crisfield soldiers who died in World War I: Julius Blades, William Blueford, Stanley Cochrane, Ronald Daugherty, Athol Gibson, Charles Lankford, Elsworth Powell, George Sterling, and George Cobb Wharton.

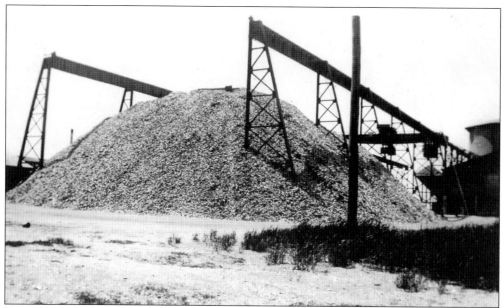

LIME PLANT. For many decades, local seafood packers disposed of their oyster shells at this plant, where they were crushed into lime for use in fertilizer and animal feed. As the oyster industry dwindled, the lime plant fell into disuse. In 1976, the Steuart Petroleum Co. purchased the plant to use as a headquarters for repairing oil barges and other vessels. It was demolished in 2003 as part of Crisfield's ongoing waterfront development.

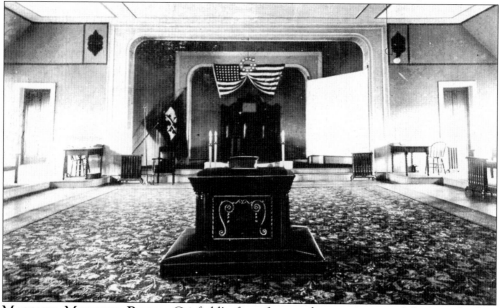

MASONIC MEETING ROOM. Crisfield's first fraternal organization, Masonic Lodge, Chesapeake No. 147 Ancient Free and Accepted Masons, was founded in 1869. The Masons first met above the oyster house of James Goodsell, the lodge's first master, in Goodsell's Alley. Following several changes in location, the lodge moved into the Gibson Building at Sixth and Main Streets in 1907, then to Odd Fellows Hall at Fourth and Main Streetsin 1909. The interior of the Odd Fellows location is seen in this 1919 view.

Riggin's Store. Located at the corner of Main Street and Somerset Avenue, this store was demolished in the early 1920s to make way for the Masonic Temple.

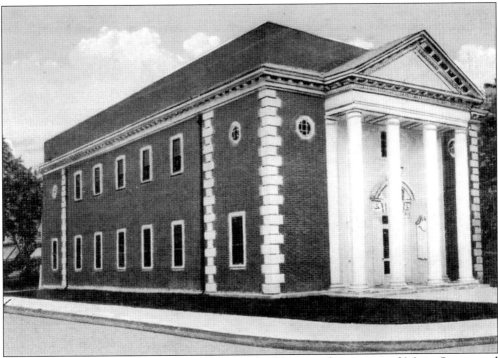

Masonic Temple. Dedicated in 1927, this building at the corner of Main Street and Somerset Avenue, seen here c. 1950, continues to serve Crisfield's Masonic Lodge.

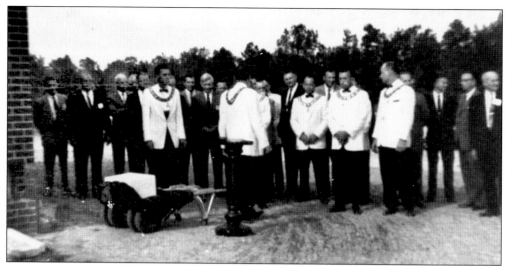

INAUGURATION OF ELKS LODGE 1044. Founded in 1906 by Harold Loreman Sr. and Carroll Crocket, the Crisfield Benevolent, Protective Brotherhood of Elks Lodge 1044 met at various locations throughout the years until a permanent home on Crisfield Highway was dedicated October 16, 1960. Officers in the white jackets at the dedication ceremony are, from left to right, Charles Howard, Paul Dorsey, Harry T. Phoebus, Jimmy Landon, Bobby Betts, Biddie Tull, and Robert "Puckers" Parks.

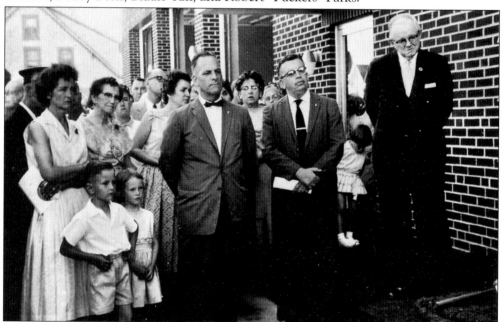

DEDICATING THE FIRE HALL. Founded in 1874, the Crisfield Volunteer Fire Department originally was based at Andrew Polyette's Livery Stable behind J. F. Loreman's blacksmith shop at Ninth and Main Streets. Later the department moved to a building on Broadway behind city hall and finally to its current location on West Main Street. The cornerstone for the current, $120,000 brick building was laid in 1961 during the ceremony seen here. Celebrants included Mayor Charles "Babe" Dryden, center, and Gov. J. Millard Tawes, right.

Five

SCHOOLS

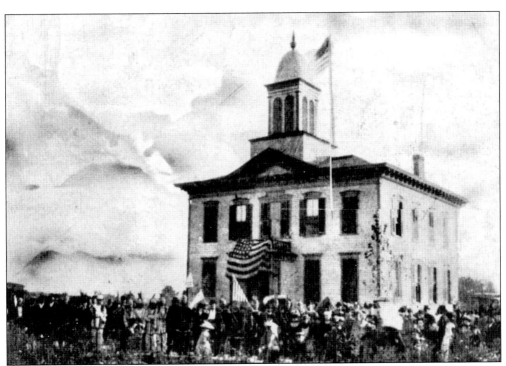

CRISFIELD ACADEMY. Constructed on Asbury Avenue in 1876, Crisfield Academy was the city's second high school and the first to be informally called Crisfield High School. Tubman Ford served as the school's first principal. The building was converted into Crisfield Elementary School in 1908 and continued in that facility until its demolition in 1937. Most recently, H. DeWayne Whittington Primary School, built in 1960 as Crisfield Elementary School No. 1, stood at the Crisfield Academy's former location.

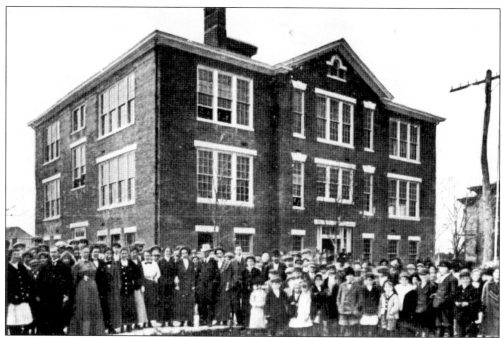

FIRST CRISFIELD HIGH SCHOOL. The first building to officially carry the name Crisfield High School was constructed on Asbury Avenue in 1908. Used only until 1926, the red brick building was the shortest-lived of all the city's public secondary school buildings. It was replaced after only 18 years because of overcrowding and classroom sizes.

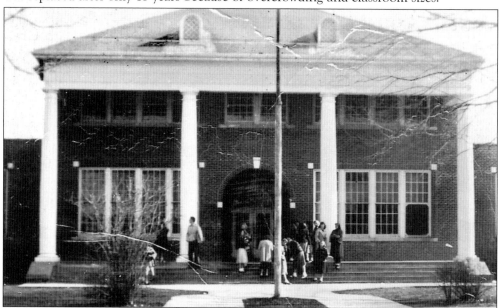

SECOND CRISFIELD HIGH SCHOOL. A new Crisfield High School, featuring a columned façade, was built in 1926 to replace the 1908 high school. The 1926 building was located on Somerset Avenue near where the current high school stands. Still in use in 1953, following the opening of a more modern high school building on the same site, the 1926 building was destroyed in a fire on February 2, 1972.

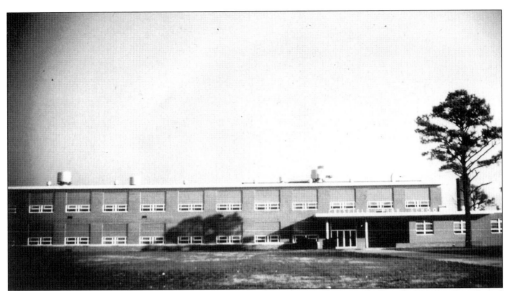

Third Crisfield High School. School officials modernized Crisfield's high school in 1953 with the construction of yet another building. Following the 1972 fire, a new Crisfield High School was built, incorporating part of the 1953 school with a more modern design. The 1972 school was renovated in 1997 with the addition of an elevator and new facilities to comply with the federal Americans with Disabilities Act of 1990.

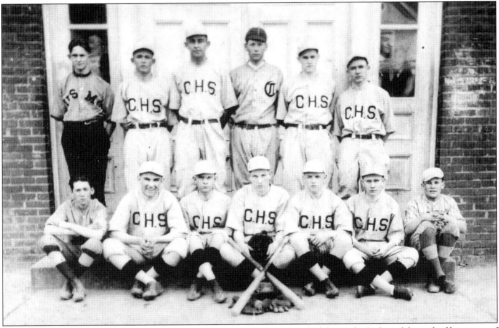

Crisfield High School Baseball Team. The Crisfield High School baseball team of 1924 consisted of a baker's dozen of strapping young lads. Pictured from left to right are (first row), mascot Johnnie Parks, third baseman Morris Sterling, Snow Ward, William Johnson, William Quinn, pitcher Clinton Daugherty, and catcher Randal Holland; (second row) fielder Edgar Carman, pitcher Ervin Sterling, first baseman Earl Cullen, shortstop Noah Dize, and fielders Lyle Quinn and Marvin Tawes.

CARTER G. WOODSON HIGH SCHOOL. Located near Charlotte Avenue at the site of the former Corbin Mausoleum, Woodson High School replaced Crisfield's former African American high school on Collins Street, which served the area from 1880 through the early 1940s. Seen here following an enlargement in 1951, the building remained a high school until 1969, when mandatory desegregation saw its students relocated to Crisfield High School. The Woodson building then served as a middle school until 2004, when it was closed for conversion into an elementary school.

JACKSONVILLE ACADEMY. Crisfield's first high school, Jacksonville Academy, was built in 1874. Seen here long after its final use, the building has since been demolished.

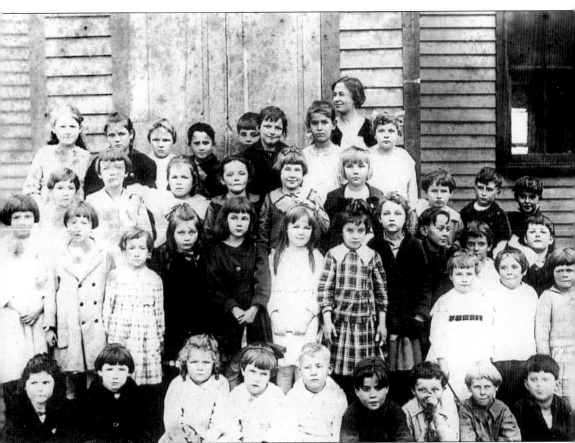

ASBURY ELEMENTARY SCHOOL. As one of many elementary schools built to serve the area from the mid-19th century through the first part of the 20th century, Asbury Elementary School was located in Crisfield's Down Neck section next to Bennet's Memorial Church. First- and second-grade students in this 1919 photograph, from left to right, are (first row), Josie Coulbourne, Lelia Nelson Culp, Nellie Jane Maddox Reuben, Kathryn Evans Myers, Harlan Tyler, Maxwell Tyler, Earl Nelson, Woodrow Mister, and Richard Sterling; (second row) Teresa Milbourne, Flora Sterling, Dollie Riggin, Inez Wilson, Gladys Hall Powell, Alma Tyler, Helen Wilson, Vesta Byrd, Elizabeth Sterling Tull, Ruth Sterling Bethard, and Ruby Mears Adams; (third row) Elizabeth Sterling Lawson, Norma Byrd, Essie Mister Purcell, Elizabeth Tyler Riggin, Mleva Mister, Virginia Nelson, Leroy Nelson, Richard Nelson, and Carson Lawson; (fourth row) Emily Maddox Williams, Cecile Wilson, Norris Ennis, James Tyler, Clifton Mister, Jeanette Tyler Bozman, Viva White Harrison, Vester Sterling Dorman, Davis Horsey, George Berry Sterling, and Russell Tyler. Standing in back is teacher Mabel Sterling.

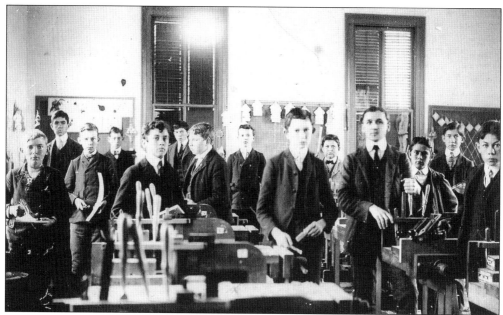

CRISFIELD ACADEMY CLASS OF 1904. Casual dress was not an option for students when this early-20th-century photograph was taken, though they probably were dressed up a bit more than usual for class photograph day. This unique picture is one of few showing the inside of the school.

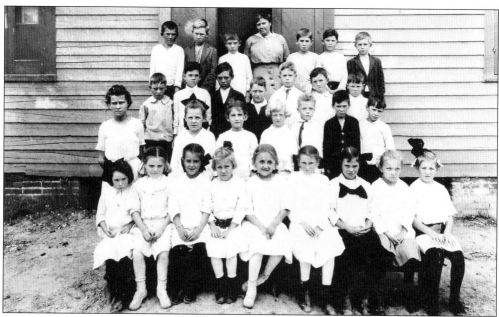

GUNBY'S COLLEGE. Located at First Street and Columbia Avenue, Gunby's College was another of Crisfield's elementary schools. Albert Goodrich was appointed principal in 1909, shortly before this fifth-grade class photograph was taken c. 1915. The school closed in 1928, after which the building served as an election house until 1969. It was then moved to the corner of Crisfield Highway and Old State Road in Hopewell, where today it serves as Highway Holiness Church.

Six

CHURCHES

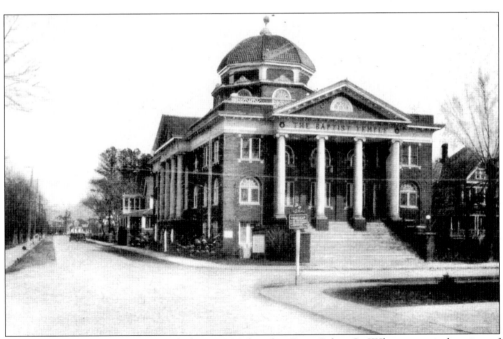

THE BAPTIST TEMPLE. Founded in 1890 by the Rev. John S. Wharton at the site of the current Church of God on Maryland Avenue, the First Baptist Church of Crisfield constructed its current building, the Baptist Temple, at the corner of Somerset Avenue and Main Street Extended in 1922. The $95,000 building has served the church's congregation since then with little external change. This 1940s view includes a street sign pointing the way to Lawsonia, Pocomoke City, and Salisbury.

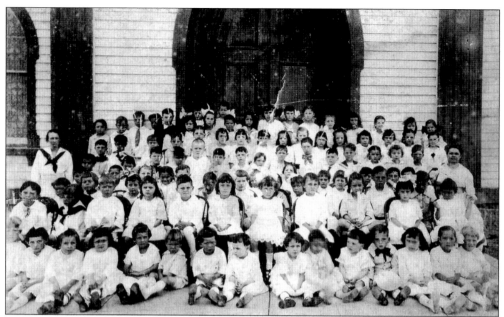

ASBURY CHURCH CLASS. This Sunday school class posed outside the fourth Asbury Methodist Episcopal Church in the late 19th century. The church stood near where the current Asbury United Methodist Church Cemetery entrance is today. The Rev. Thomas Carron organized Asbury Church in 1810. The first service was held that year at the home of Hance Lawson near Jenkins Creek. (Courtesy Randy Laird.)

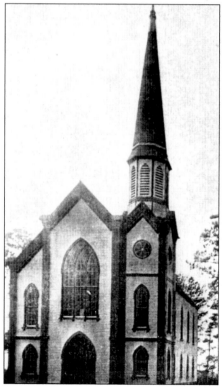

ASBURY METHODIST EPISCOPAL CHURCH. Constructed in 1880, this wooden incarnation of Asbury Church (seen close up in the photograph above) was destroyed in a fire in 1919. A $250,000 granite structure similar to the current church replaced this building in 1923.

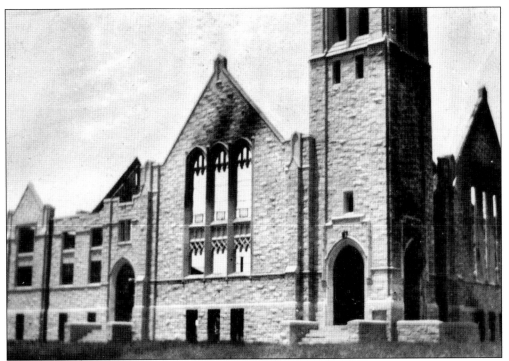

ASBURY FIRE OF 1927. Fire once again claimed Asbury Church in 1927, only four years after the fifth building's construction. The congregation dedicated individual shingles to donors who pitched in to help fund the new roof, windows, and interior repairs.

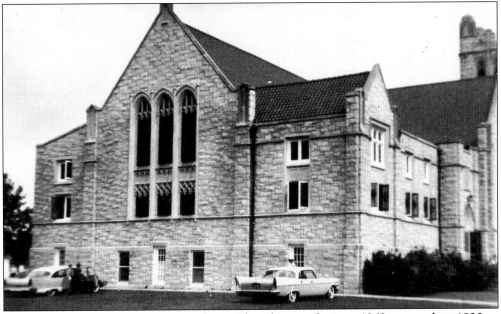

ASBURY REBUILT. The current Asbury Church, seen here c. 1962, opened in 1930 at the corner of Lawsonia Road and Asbury Avenue. A four-inch water main was installed with the reconstruction, connecting the church with a city main to ensure an adequate water supply for firefighters in the event of future blazes.

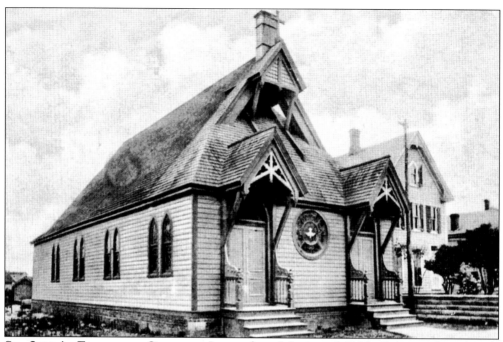

St. John's Episcopal Church. Located at Main and Fifth Streets, this church hosted a variety of community events in the 1930s, including a series of popular annual Halloween dances. However, with much of its congregation leaving for military bases and overseas assignments during World War II, the church became a casualty, failing to reopen following the war.

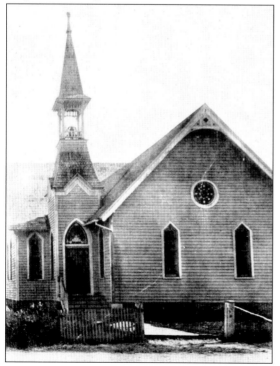

Bennets Memorial Methodist Protestant Church. Members of Masonic Epitome Chesapeake Lodge 147 Ancient Free and Accepted Masons laid the cornerstone for this church on September 22, 1898. Located in Crisfield's Down Neck section, the building now houses Wesleyan Church.

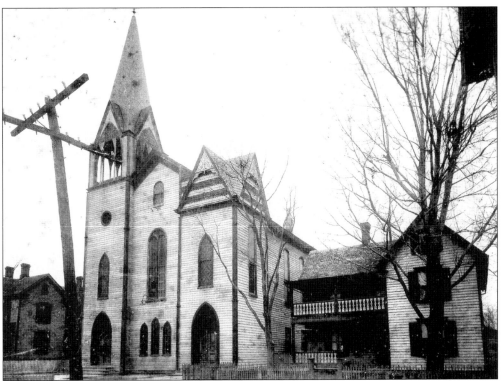

IMMANUEL METHODIST EPISCOPAL CHURCH. Organized in 1863 as a branch of Old St. Peter's Church in Hopewell, Immanuel Church has served Crisfield for more than 140 years. This building, the first permanent structure to carry the Immanuel name, was built in 1880 at the corner of Pine and Third Streets, then known as Horsey and Church Streets. (Courtesy Skip Marshall.)

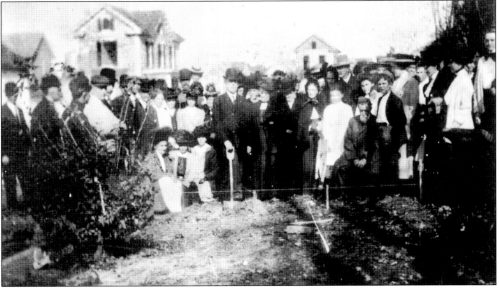

GROUNDBREAKING FOR THE NEW IMMANUEL. In 1909, ground was broken for the current Immanuel Church on Main Street. The church was built at a cost of $40,000.

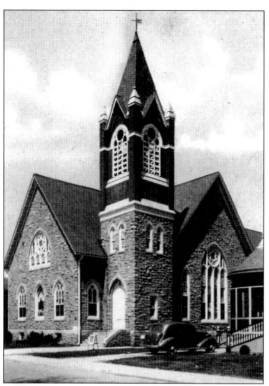

NEW IMMANUEL CHURCH. The current Immanuel Church opened in 1911 in an attempt to house the church's growing congregation. Though many parishioners have worshipped here throughout the years, perhaps the most famous was Pres. Calvin Coolidge, who attended services here during a visit to Crisfield during his time in the Oval Office.

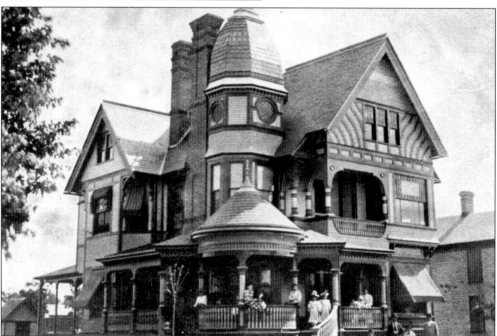

IMMANUEL PARSONAGE. One of the more unique and ornate buildings in Crisfield, this residence stood beside what is now Immanuel United Methodist Church on Main Street, serving as the church's parsonage. Now only existing in photographs, the residence is gone. A church community hall was built in its location in 1976.

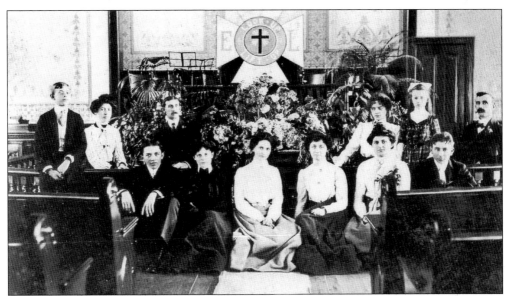

EPWORTH LEAGUE. The Immanuel Church Epworth League, *c.* 1909, included from left to right (first row), unidentified, Alice Quinn, Blanche Holland, Maude Ford, and two unidentified; (second row) two unidentified, Boss Hardester, Leana Coulbourne, Margaret Tawes, and Charlie Mallison.

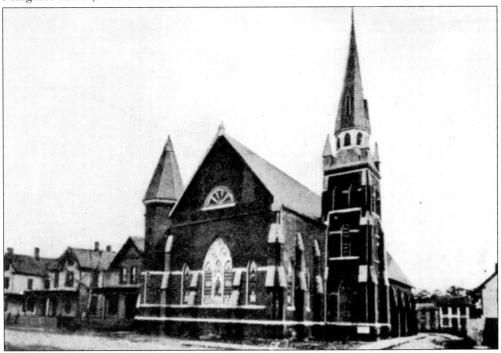

MOUNT PLEASANT METHODIST EPISCOPAL CHURCH. This church was founded in 1876, when its first building was constructed at its present location on Main Street. The inaugural building was remodeled into Gleaner's Hall before the structure pictured here was built at that same location in 1897. Weekly services are still held in the same building.

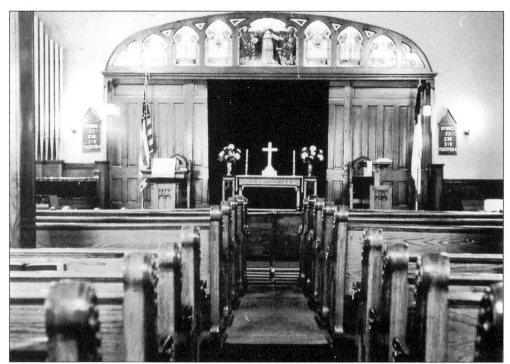

TWO VIEWS OF MOUNT PLEASANT. The interior of Mount Pleasant Church has changed dramatically over the years while keeping the church's basic structure intact. The wooden doors and ornate windows in the top photograph are located in the same position as the curtains, cross, and organ pipes seen below.

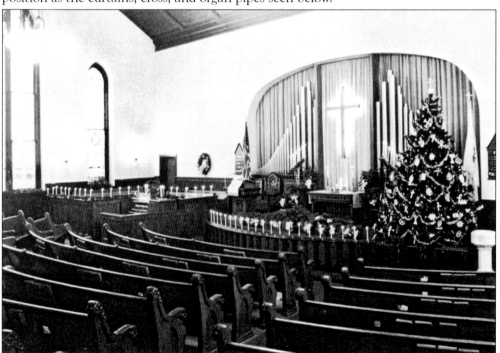

Seven

FIRES AND OTHER DISASTERS

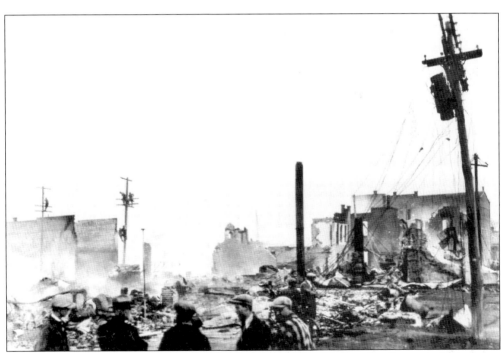

GREAT FIRE OF 1928. While fires in 1883 and 1912 were said to be the most devastating in Crisfield's history, the hallmark blaze most recall today is the Great Fire of 1928. In this photograph, telephone and electrical linemen work to restore service to the city following the inferno. Because the telephone lines burned during the fire's early stages, city officials had to drive 18 miles to Westover to call for help from outside fire departments.

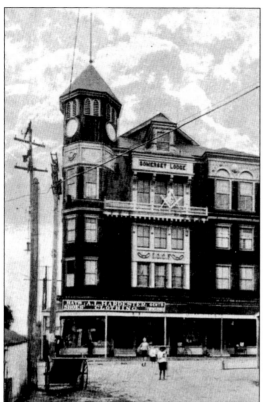

FIRE'S ORIGIN. The fire began on March 29, 1928, in the projection room of the Arcade Theater in the Crisfield Opera House (formerly Odd Fellows Hall), seen here at Fourth and Main Streets. Because the fire was thought to be minor, patrons were allowed to remain in the theater to watch the end of that evening's feature, *Love*, starring Greta Garbo.

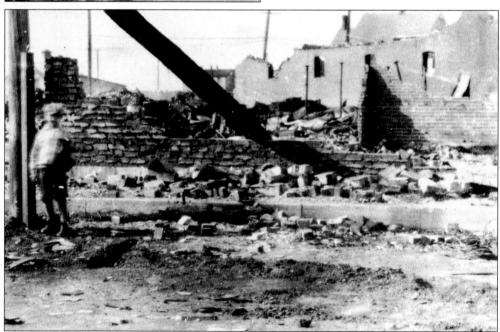

SORTING THROUGH THE RUBBLE. Once the film ended, the fire quickly spread to the building's exterior, where strong winds carried it to adjacent buildings, the ruins of which are seen in this day-after photograph.

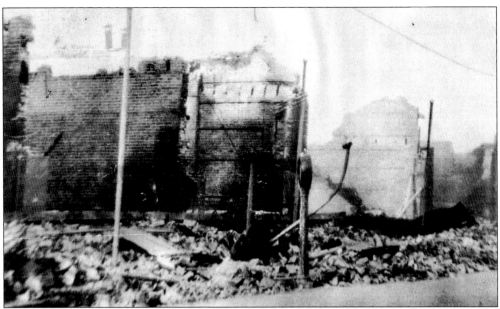

BUILDINGS DESTROYED. In all, the fire caused more than $1 million in damage and completely destroyed Crisfield's downtown area. Six fire departments helped fight the blaze, including Crisfield, Princess Anne, Pocomoke City, Delmar, and Seaford, Delaware. Despite the widespread damage, only one firefighter fatality was recorded. Frank Morgan of Crisfield suffered fatal injuries when he was struck by a pillar from a falling wall of the Gibson Building.

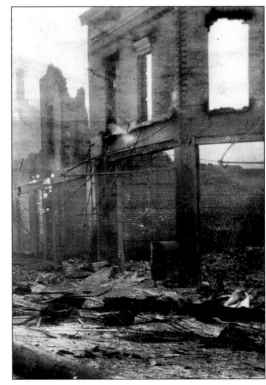

DR. WARD'S DRUG STORE. Across the street from the Opera House, Dr. Ward's Drug Store is one of the only businesses that could be identified from the photographs taken after the fire. Unlike most of the buildings, which were reduced to rubble, this one retained a portion of its façade.

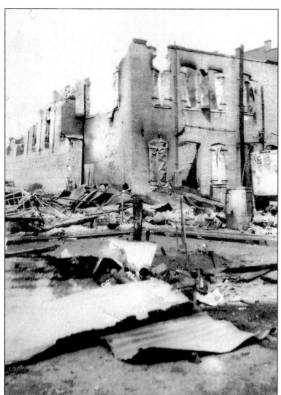

FIRE'S REMAINS. Following the fire, city officials attempted to rally businessmen and residents who lost their livelihoods and homes by adopting a "Build for the Future" campaign. While the fire was visible for more than a mile, local leaders hoped their constituents could see even farther into more prosperous times.

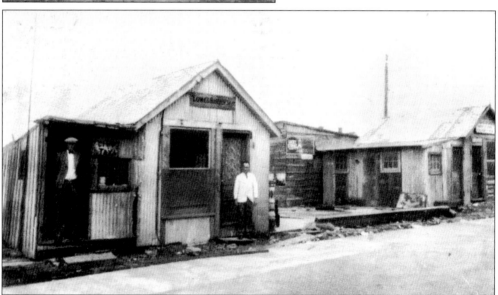

REBUILDING CRISFIELD. Many businessmen immediately rose to the challenge, reopening just days later in tin shacks constructed at the sites of their former workplaces. Temporary businesses in this view included City Taxi and Lowe's Barbershop, at left. Standing in front of the barbershop likely is George "Pete" Lowe, who founded the business at the nearby Commercial Hotel in 1915 and later employed famed local barbers and decoy carvers Lem and Steve Ward.

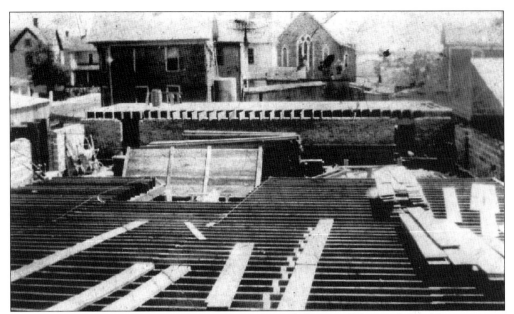

THE NEW ARCADE. George "Pony" Lawson and George "Tommy" Maddrix, owners of the Arcade Theater, vowed to come back as well. Building a grand new theater, the beginnings of which are seen here, they named the structure the New Arcade, offering a nod to the past with an eye toward the future.

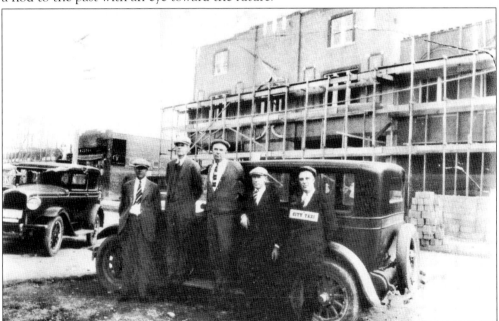

RETURNING TO NORMAL. Scaffolding surrounded the nearly completed New Arcade when this photograph was taken in 1929. Business had begun to return to normal for companies like the City Taxi. Meanwhile city officials took advantage of the widespread destruction by incorporating wider streets and more parking into the reconstructed downtown area. Pictured from left to right are unidentified, Arthur Record, Pluck Daugherty, China Charnick, and unidentified.

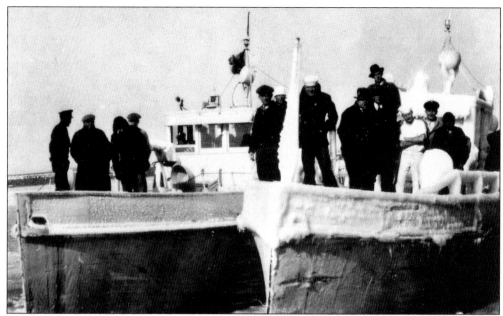

BLIZZARD OF 1936. The worst blizzard in Crisfield's history, the blizzard of 1936, blanketed Tangier Sound in ice for more than two weeks, making passage nearly impossible. On February 7, the U.S. Coast Guard cutter *Travis*, built to withstand the harshest conditions, became stuck in the ice while attempting to blaze a path from the mainland to Tangier Island, Virginia. A second cutter, the *Apache*, responded to free it three miles outside Crisfield.

SGT. WILBERT HUNTER. That same day, volunteers from Crisfield joined the Maryland State Police in carrying two sleds of food and medicine across the ice for the *Travis* to deliver to Tangier. More than 100 island residents already had made the trip to Crisfield on foot across the icy surface. During the expedition, state police sergeant Wilbert Hunter, seen here that morning in Crisfield, fell through the ice, dying of exposure shortly thereafter en route to the *Travis*.

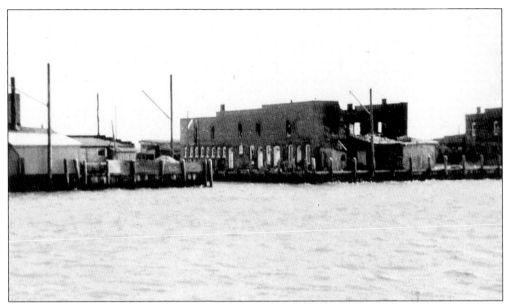

GEO. A. CHRISTY AND SON SEAFOOD FIRE. A 6:00 a.m. blaze caused an estimated $100,000 in damages to Geo. A. Christy and Son's Jersey Island seafood plant on February 1, 1944. Winds spread the fire to the adjacent Crisfield Shipbuilding Company. The inferno also engulfed about half a mile of nearby marsh. Along with 7,000 fish boxes and most of the processing equipment, the fire claimed 5,500 bushels of oysters.

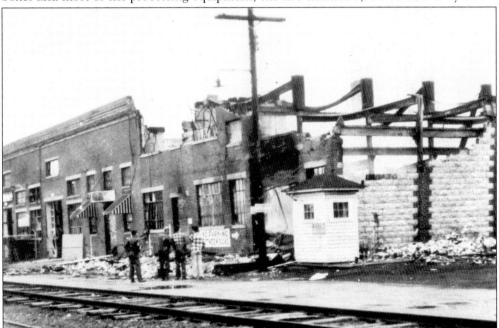

BRIDDELL'S FIRE. In March 1951, a switch box caught fire in the packing room of Chas. D. Briddell, Inc., on Main Street, igniting several nearby drums of flammable lacquer. The resulting blaze and explosions destroyed the plant, the remains of which are seen here. The disaster placed 175 of Briddell's 260 employees out of work until completion of a new factory on Crisfield Highway in 1953.

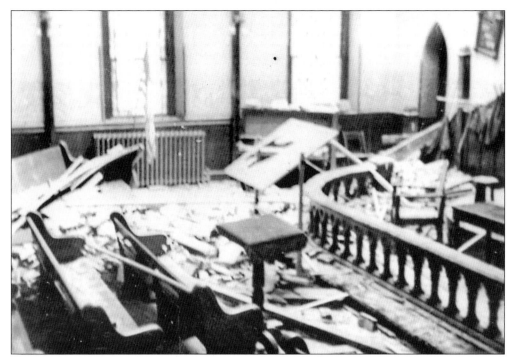

HURRICANE HAZEL. The worst storm in Crisfield's history, Hurricane Hazel, wiped out much of the city on October 15, 1954. Not only its winds, but also the high tides it caused demolished many boats and buildings throughout the area. Here the results inside Mount Pleasant Church on Main Street are seen the day after the storm.

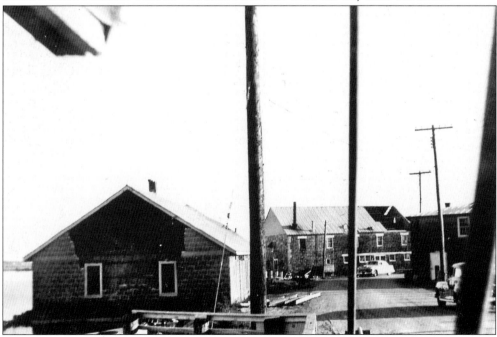

MORE DAMAGE. Roofs were blown off and buildings battered on Jersey Island, seen here from the foot of the drawbridge.

OFF WITH THE ROOF. A look at the exterior of Mount Pleasant Church offers another view of the extensive damage caused by the hurricane. Maryland Army National Guard Company L was called in to help clean up the church. The soldiers were able to save the organ and a few pews, but not much else within the sanctuary.

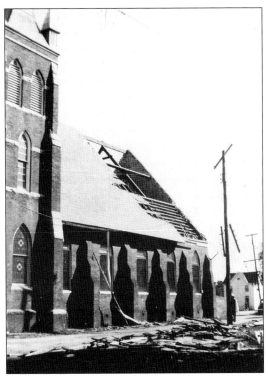

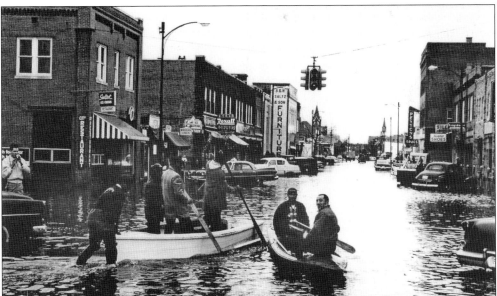

GREAT TIDE OF 1962. This photograph, taken down Main Street while standing at Fourth Street, shows the extent of the high-tide flood that overtook much of the city March 6 and 7, 1962. This view also offers a good look at the businesses in that section of the city during that time. On the left are the City Restaurant, Vet's Cab, Western Union, Kent Pharmacy, McCrory's, and S. and N. Saltz and Son Furniture. On the right are Sears, Gunter Brothers Appliances, Bata Shoes, Silco, and Peyton's Pharmacy. (Courtesy Scorchy Tawes.)

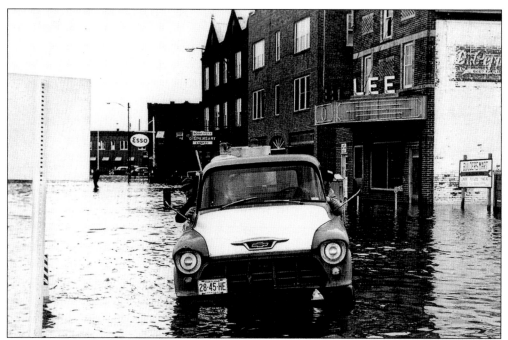

LEE THEATER. These men attempted to weather the flood in a Chevrolet pickup truck, driving past the Lee Theater on Main Street. Other businesses seen in the background include the Somerset County Dispensary and an Esso service station. (Courtesy Scorchy Tawes.)

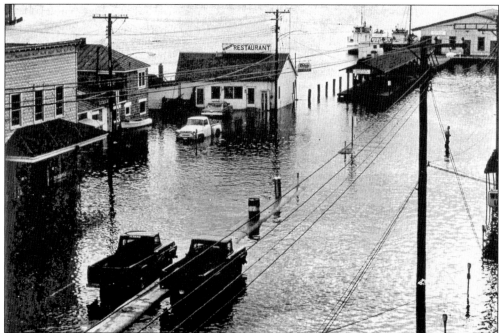

FLOODING AT THE DEPOT. The steamboat wharf and railroad depot area at Crisfield Harbor saw the most intense flooding. Water is seen reaching the door of Windsor's Seafood Kitchen in this view. (Courtesy Scorchy Tawes.)

Eight

MAIN STREET AND BEYOND

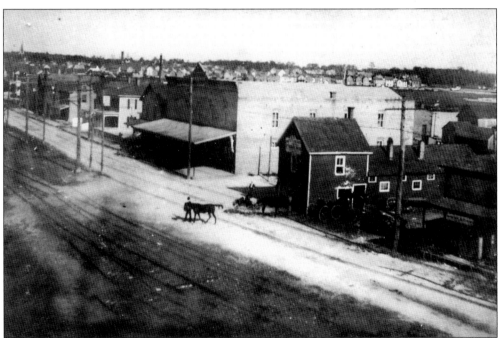

EARLY DAYS. Despite the dirt roads, this late-19th-century photograph of Ninth and Main Streets may seem familiar even by modern standards. J. F. Loreman's blacksmith shop, in front of which the man and his horse are standing, is located at the current site of Watermen's Inn restaurant. The large brick building, which once housed Horsey Brothers Store, is now owned by Metompkin Bay Seafood. The building next door, now Gordon's Confectionery, served as the city jail.

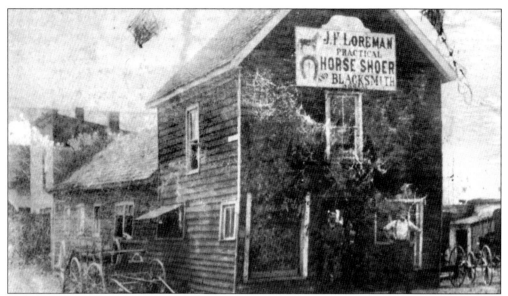

J. F. LOREMAN'S BLACKSMITH SHOP. Seen in the photograph above, this is where international cutlery magnate Charles Briddell is said to have learned his craft by watching master blacksmith Jim Loreman. Andrew Polyette's livery stable, behind the blacksmith shop, was the first home of the Crisfield Fire Department's horse-drawn Clapp and Jones pumper, purchased in 1885. Loreman is pictured to the left in this 1888 image beside customer Henry Revelle.

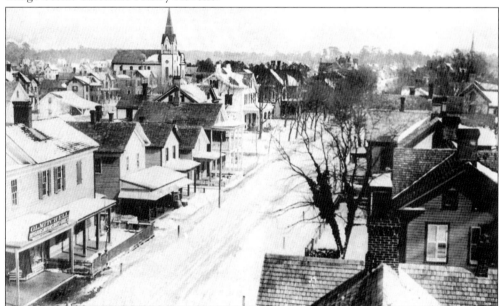

AERIAL VIEW. This late-19th-century photograph shows the view from the top floor of Odd Fellows Hall on Main Street. Prominent buildings include the O. L. Mitchell dry goods store to the far left and Dr. Ward's Drug Store to the far right. The steeple of Immanuel Church, as it stood on Pine Street, can be seen in the distance. Other buildings seen here include homes owned by Charlie Daugherty, Bill Landon, J. P. Tawes, Harvey Reese, and Dr. Will Colbourne.

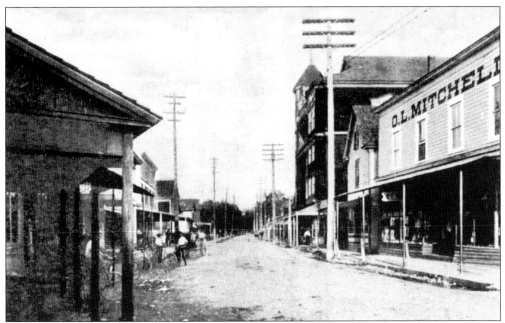

O. L. Mitchell Dry Goods. The O. L. Mitchell dry goods store was one of the most prominent businesses in Crisfield in the early 20th century, seen at the right. It had moved to the corner of Fifth and Main Streets by the time this view was created in 1910. Along with groceries, the business sold boots, shoes, and notions.

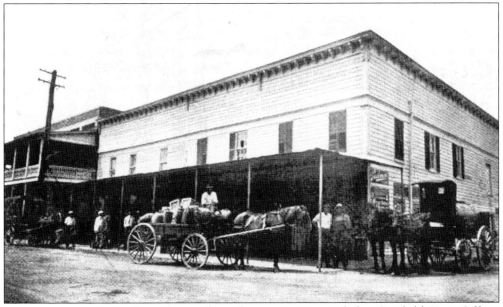

N. W. Tawes and Son. Located at the current site of the Crisfield Post Office, N. W. Tawes and Son was one of Crisfield's most successful wholesale grocers for decades. Founded by Capt. N. Wesley Tawes in the 1880s, the business became the O. L. Tawes Company upon his death in 1912, when son Orrie L. Tawes and business partner Olin L. Sterling took over. The business moved to Fifth Street once the original building, seen here in 1911, was destroyed in the Great Fire of 1928.

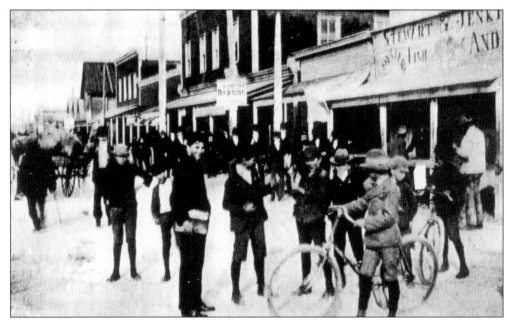

STEWART AND JENKINS FISH MARKET. Though many residents were involved in the actual processing of seafood, many locals bought their fish and oysters from establishments such as the Stewart and Jenkins Fish Market, seen here in 1904.

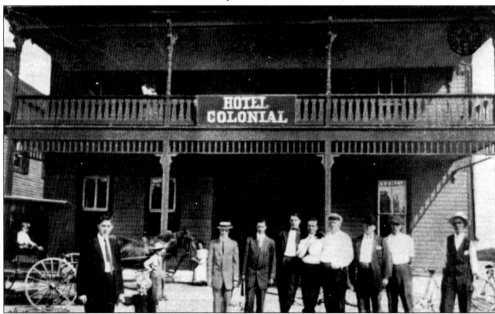

COLONIAL HOTEL. Businessman Joseph Disharoon built the Crisfield Hotel on Main Street in the late 19th century. One of the city's finest showplaces, the hotel originally was managed by Disharoon's brother, Lawrence. For reasons unknown today, the hotel's name was changed to the Colonial Hotel in the second decade of the 20th century. Lawrence Disharoon became the hotel's owner in 1915. Following Lawrence's death in 1933, Somerset Hotel owner James Byrd bought the Colonial Hotel and changed its name back to the Crisfield Hotel.

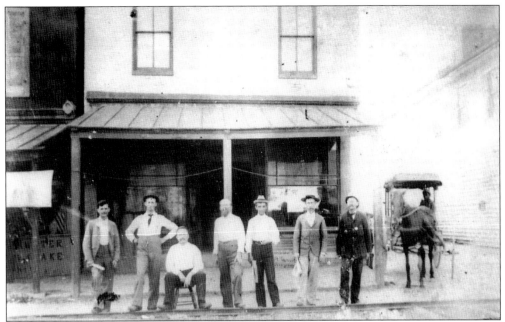

J. P. TAWES AND BROTHER HARDWARE. Founded by J. A. Hearn and Company in 1869, J. P. Tawes and Brother Hardware has been a fixture in Crisfield for more than 130 years. It acquired its more familiar name in 1886 when John P. and Oliver Cope Tawes purchased the store from its original owners. Pictured at the store in 1890 from left to right are John Riggin, Robert Tawes, Oliver Cope Tawes, John P. Tawes, Billy Byrd, Isaac Byrd, Sid Riggin, and Manny Wix in the carriage. (Courtesy George Tawes.)

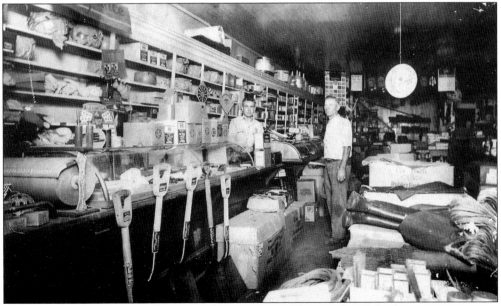

INSIDE J. P. TAWES AND BROTHER HARDWARE. The inside of the business is seen in this 1935 view. M. Dana Tawes appears behind the counter, with customer Capt. Walter Catlin in front. The wooden structure was replaced by a new brick building, where the business still operates today.

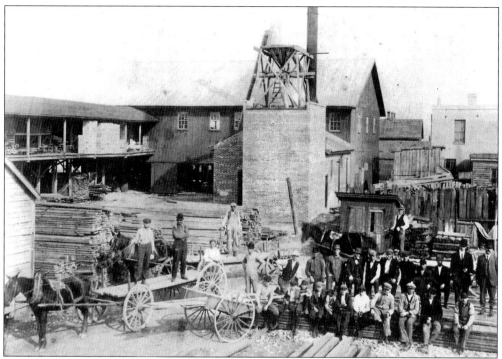

MUIR LUMBERYARD. Founded in 1908, this business comprised an entire city block. Seen here c. 1910, the company later became the A. B. Cochrane Company and even later Tawes Brothers Lumber Company. The business served the area until 1987, when suspected arson at the lumberyard sparked a fire that burned much of the downtown area.

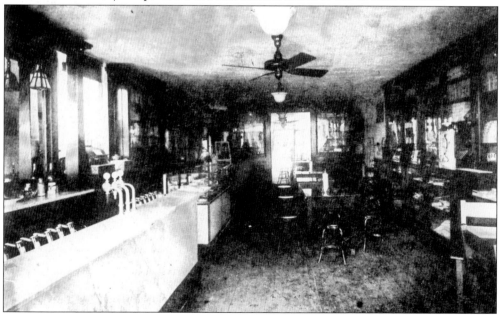

SODA FOUNTAIN. This 1900 soda fountain was one of many businesses that dotted Crisfield's streets at the beginning of the 20th century. One of the biggest attractions here likely were the ceiling fans, which kept patrons cool in the summertime.

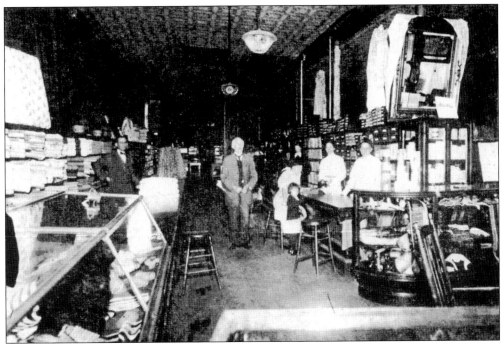

HORSEY BROTHERS STORE. Located on West Main Street near the current site of Gordon's Confectionery, this store is another example of the non-seafood businesses that thrived in Crisfield around 1900.

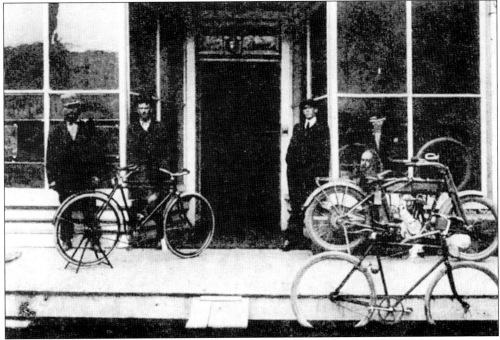

BICYCLE SHOP. Prior to the automobile, bicycles gained popularity in Crisfield as an alternative to horse travel. Shops like this one, *c.* 1900, helped keep those bicycles running with tires and repair services.

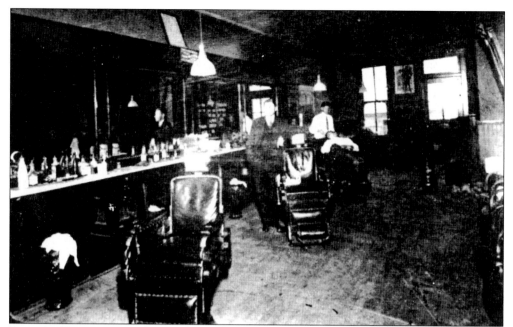

LOWE'S BARBERSHOP. Located at the Commercial Hotel on Main Street, Lowe's Barbershop opened about 1915. Initially shaves cost 10¢ and haircuts 20¢, except after 6:00 p.m. on Saturdays, when demand forced the price of haircuts up to 25¢.

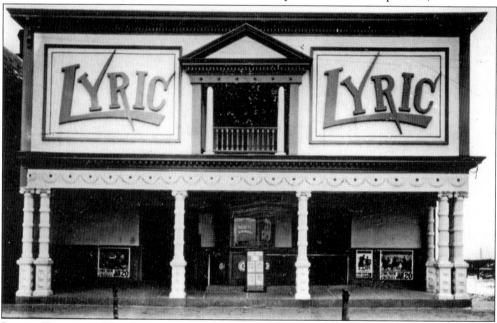

LYRIC THEATER. The Lyric Theater was the place to be in downtown Crisfield when this photograph was taken in 1905. Located at Main and Fifth Streets, the theater initially showed only silent films before moving to talkies, predominately westerns, once the technology made its way to Crisfield. The theater became a casualty of the Great Fire of 1928, located only two doors down from the fire's origin. Admission was 25¢ for adults at the time of the Lyric's demise.

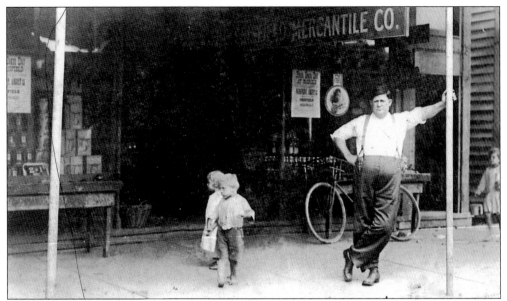

CRISFIELD MERCANTILE COMPANY. The Crisfield Mercantile Company, seen here in 1911, sold everything from groceries to household items. The man leaning on the post is believed to be Dan Collins. Posters in the windows advertise Frank "Home Run" Baker Day in Crisfield on Friday, August 11, saluting the major league slugger from the Eastern Shore.

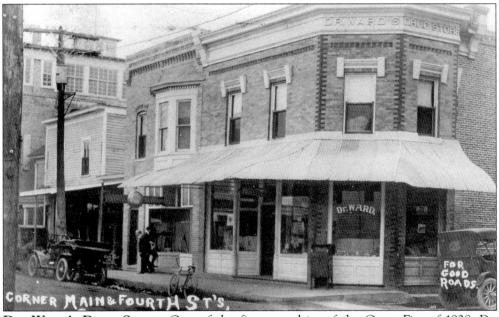

DR. WARD'S DRUG STORE. One of the first casualties of the Great Fire of 1928, Dr. Ward's Drug Store stood at the corner of Main and Fourth Streets when this photograph was taken *c.* 1915. Automobiles had begun to infiltrate Crisfield's streets by then, prompting a call for better roads. To the left of the drug store is the business of jeweler Harry Tilghman, denoted by the pocket watch-shaped sign hanging from the awning. (Courtesy Raymond "Tighty" Mister.)

CRISFIELD LIGHT AND POWER COMPANY. Built in 1911 near Maryland Avenue, the Crisfield Light and Power Company supplied the city's first gas lines. Owned by a Mr. Layton and Mr. Owens, the company prospered for many years, laying an estimated 26 miles of lines. However, poor maintenance allowed those lines to deteriorate, and the company was forced to sell. The Suburban Propane Company eventually bought the business.

ANKLIN'S GARAGE. Owned by Walter Anklin, this business was one of the first in Crisfield to service automobiles. As noted by the many signs in this early 20th century view, it specialized in Seiberling tires. The garage was one of many establishments destroyed by the Great Fire of 1928.

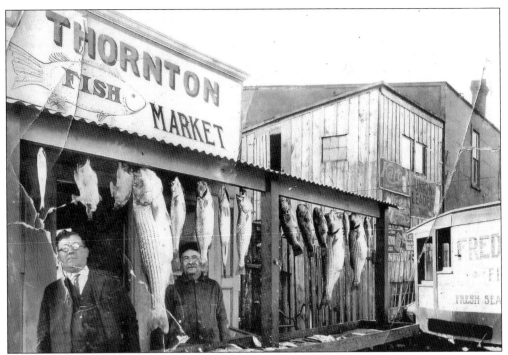

THORNTON FISH MARKET. Fred Thornton, seen at right, operated this market in Crisfield *c.* 1920 near the Jersey Island Drawbridge. It later became Greenie's Market. Pictured with Thornton is George Davis. Signs to the right advertise Karo Syrup and Union Leader tobacco. (Courtesy Cabby Dize Jr.)

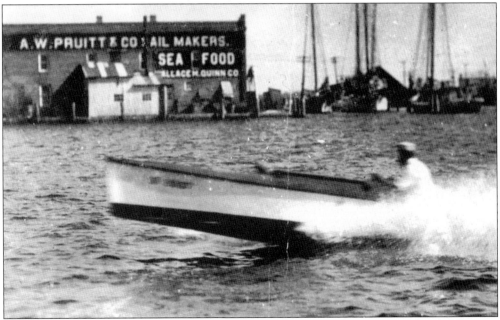

A. W. PRUITT COMPANY. This speedboat racer blazes a trail past two of Crisfield's most venerable businesses, A. W. Pruitt and Company Sail Makers and Wallace M. Quinn Seafood Company, in this view of Crisfield Harbor *c.* 1920.

UPTOWN. Gasoline and other goods could be purchased on Main Street when this early-1920s photograph was taken. The tall building to the far left is the Crisfield Opera House, also known as Odd Fellows Hall.

WEBB PACKING COMPANY. Specializing in scrapple and other Eastern Shore delicacies, the Webb Packing Company had plants in several cities and towns throughout the Delmarva Peninsula, including Crisfield, as seen in this 1920s view.

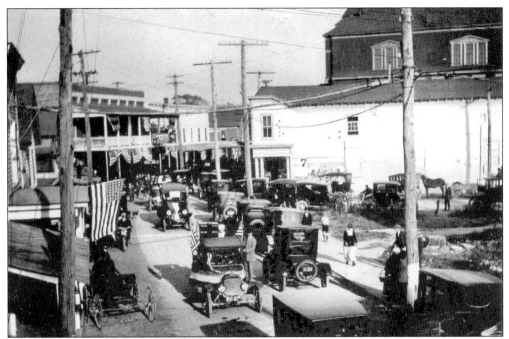

COMMERCIAL HOTEL. Cars lined Main Street for a patriotic celebration during the first week of October 1921. Besides offering a look at Crisfield at its most decorated, this image offers a rare view of the Commercial Hotel near Fifth Street. The large white building to the right is the Lyric Theater.

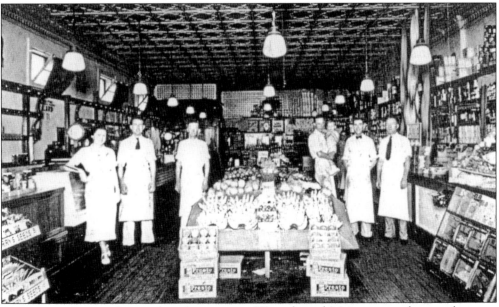

AMERICAN STORE. Located at the corner of Fourth and Main streets, later to become Hilda's City Restaurant, the American Store was long a staple of Crisfield. Pictured from left to right in this 1930s image are Lois Dize, Raymond Walker, Vernon Outten, John Byrd, John Parks, and Paul Ruark. The store later moved farther up Main Street as part of the Acme Markets chain, which left Crisfield in the 1970s.

GORDON'S CONFECTIONERY. No book about Crisfield would be complete without a photograph of Gordon's Confectionery, the city's most venerable restaurant. Founded as Gordon's Place in 1928 by Gordon Evans Sr., the business has changed somewhat since this photograph was taken c. 1935, but some items, like the candy case to the left, remain into the 21st century. Pictured from left to right are unidentified, Ed "Mitch" Evans, Gordon Evans Sr., and shoemaker Charlie Kaufman. (Courtesy Kenny Evans.)

PEYTON'S PHARMACY. Founded in the early 1890s as Hall and Atkinson Druggists, the name of this business changed to Hall, Atkinson, and Company with the addition of Dr. William Peyton as a business partner in 1894. By 1930, Peyton had controlling interest of the company and changed its name to Peyton Pharmacy. The business's original West Main Street building burned that year and was reopened in the uptown location most Crisfield residents today recall, seen here c. 1948. The pharmacy closed in the late 1980s.

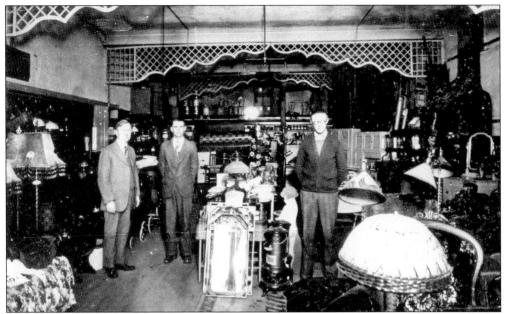

FRANK P. LANDON FURNITURE. Along with clothing and shoes, retailer Frank P. Landon offered a line of furniture at his Main Street store. Landon's was unique among Crisfield businesses in that it once offered its own trading stamps. Many local businesses offered the more common S and H Green Stamps, which unlike the Landon's stamps could be traded nationally.

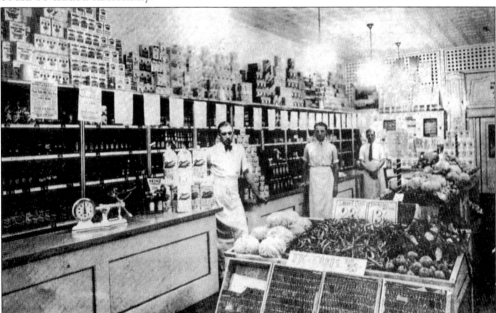

TULL GROCERY STORE. Bob Tull, seen here with clerks King Sterling and Bert Wilson, owned this establishment, located in the Main Street building that later housed Kent Pharmacy. Two pounds of fig cakes sold for just 23¢ when this photograph was taken in 1933. Sweet corn went for 23¢ a dozen, butter 29¢ a pound, flour 49¢ for a 12-pound bag, and sugar at 49¢ for a 10-pound bag.

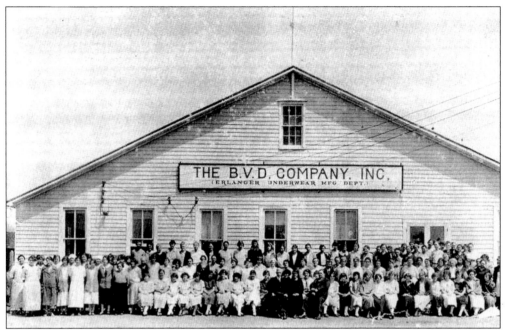

THE BVD COMPANY. The underwear manufacturer was among Crisfield's many garment factories when this photograph was taken, *c.* 1930. Among those employees pictured is seamstress Clara Sterling. (Courtesy Scorchy Tawes.)

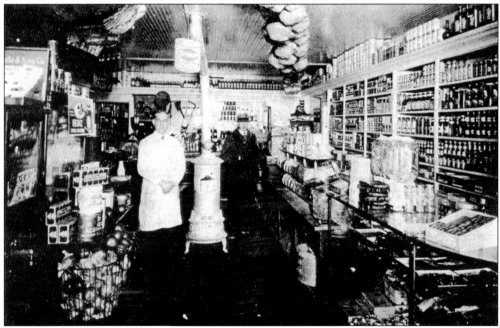

W. E. GODMAN'S STORE. The shelves of W. E. Godman's store on Main Street were well stocked with groceries when this photograph was taken around 1912. Famous for "Godman's Good Groceries," as its advertisements proclaimed, the store was in operation for nearly half a century. Pictured from left to right are W. E. Godman and customer J. Lloyd "Judge" Truitt.

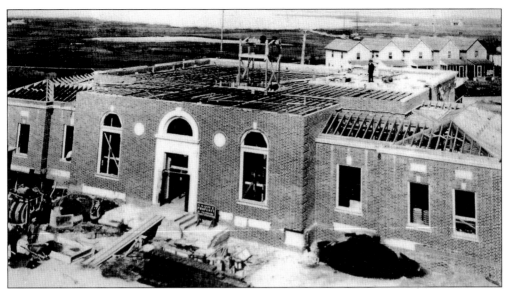

BUILDING THE POST OFFICE. Postal service to Crisfield was established in the Jacksonville section on July 16, 1861. Throughout the years, Crisfield's post office shifted to a number of private residences until 1915, when it was established in space leased at the current site of Clarence Sterling and Son Marine Hardware on West Main Street. In 1932, government officials purchased land at the corner of Fourth and Main Streets to build a permanent, federally owned post office in Crisfield.

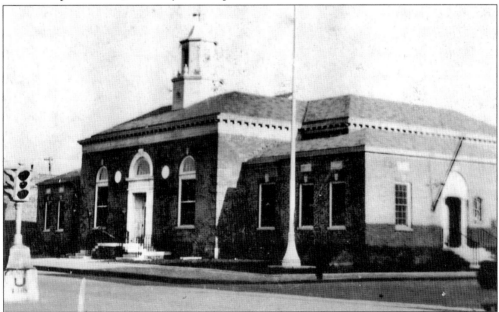

THE STOPLIGHT. Opened in 1933, the post office has served Crisfield with few changes. In 1999, postal officials added a ramp to the main door to comply with federal Americans with Disabilities Act regulations. The customs house to the right of the building closed in 1971. However, perhaps the most striking image in this view is the street-mounted stoplight, later replaced by a hanging model. The hanging light was removed with the demolition of one of its anchors, the New Arcade Theater, in 1995.

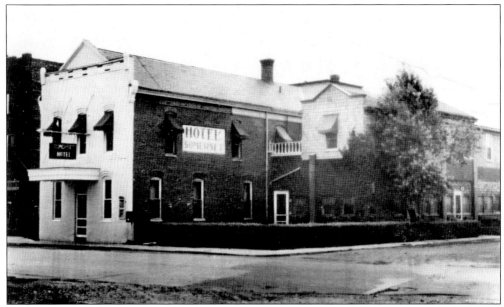

SOMERSET HOTEL. Located at Sixth and Main Streets, the Somerset Hotel was one of three, along with the Crisfield and the Commercial, to serve the city prior to World War II. Seen here in 1938, the hotel was converted from the former Crisfield General and Marine Hospital in 1923. It closed in 1940, and the building became the Lee Theater before making way for Builders Mart in 1963 and Carson Marine in 1970. Fire demolished the structure in 1971.

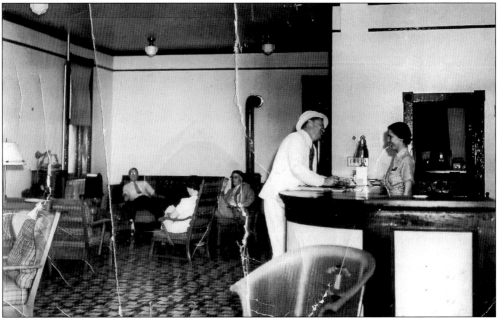

CRISFIELD HOTEL LOBBY. In its heyday, the Crisfield Hotel lobby was a favorite spot not only for guests, but also for locals who sometimes would gather for a visit. Pictured behind the front desk in this view *c.* 1940 is Pat Dorman. Sim Tilghman is seated closest to the stove. (Courtesy Raymond "Tighty" and Bobbi Jean Mister.)

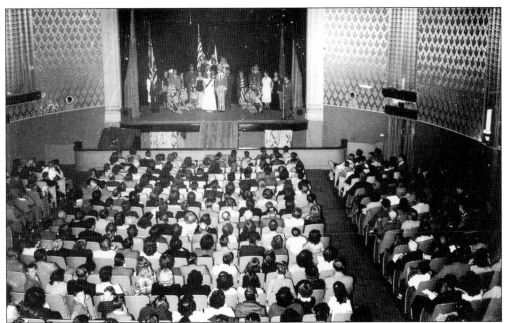

NEW ARCADE THEATER. Local school children present a patriotic program at the New Arcade Theater in this 1938 image. The theater seated more than 700. While mostly known for their movies, both the New Arcade and the nearby Lyric hosted many class plays and community productions, including fashion and minstrel shows, through the 1940s.

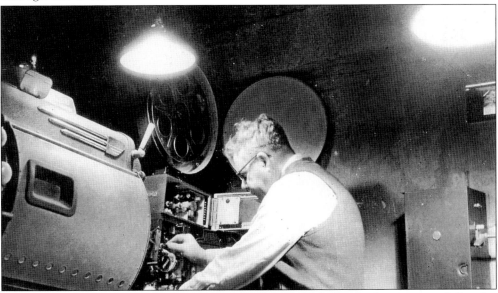

LOADING THE PROJECTOR. Projectionist John Daniels loads the next reel for the New Arcade's screen when this photograph is taken, *c.* 1950. While the movies were important, sometimes they were not enough to bring people into the theater. In the 1940s, the New Arcade hosted dish nights, offering one free dish per admission each week. Those who wanted to collect the full set would have to come back several weeks in a row.

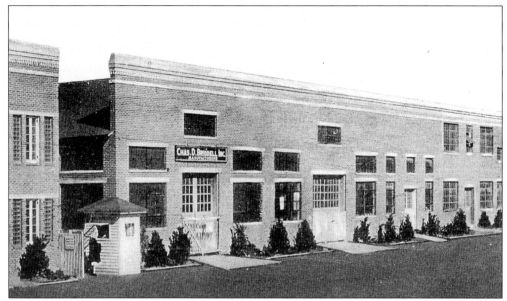

CHAS. D. BRIDDELL, INC. Born in Marumsco, Charles Briddell Sr. opened his first blacksmith shop in his backyard at age 11. In his early 20s, Briddell fashioned an oyster knife that became the industry standard and made him a fortune, which he lost several times over in an attempt to expand his business. In 1920, at age 36, he relocated his factory to this facility on Crisfield's Main Street, where he and his heirs rebuilt that fortune for many years to come.

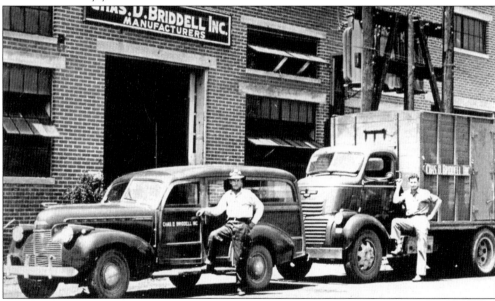

READY FOR SHIPPING. While Charles Briddell Sr. passed away in 1938, his company forged ahead. It earned the coveted "E" flag for efficiency four times from the U.S. Army and Navy for contributions to World War II, which included production of more than two million bazooka shells, pry bars, and machetes. After the war, Briddell became a leading manufacturer in everything from ice picks and muskrat traps to ashtrays and U.S. mail carts. The company even dabbled in food, selling a pre-packaged oyster puff mix.

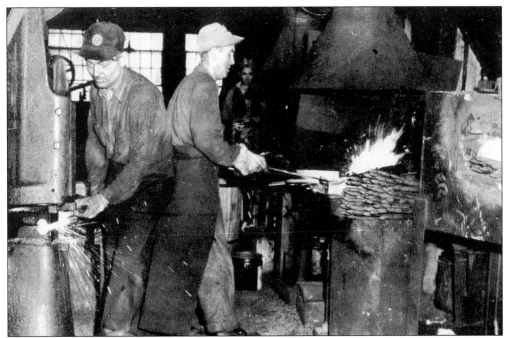

FUELING THE FIRE. The diversified products allowed Briddell to employ more than 300 people, including those seen here. However, the company's real calling did not emerge until 1946. That year, employee Paul Culver developed a letter opener as a Christmas gift to the Briddell family. With Culver's help, the Briddells transformed that design into a steak knife and marketed under the brand "Carvel Hall." The knives were an instant hit, grossing $1 million for the company within four weeks of their unveiling in 1951.

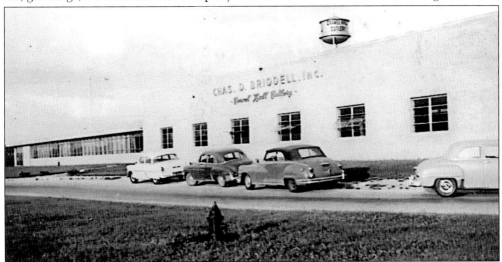

THE NEW BRIDDELL. The increased capital could not have come at a better time. One week after sales hit the $1 million mark, Briddell's Crisfield plant burned to the ground. In 1953, the family replaced it with this modern $3-million plant on Crisfield Highway and sold Carvel Hall Cutlery around the globe. In 1960, the Briddells sold the company to Towle Manufacturing Company, which continued the brand. Following several more changes in ownership, Briddell closed forever in the late 1990s.

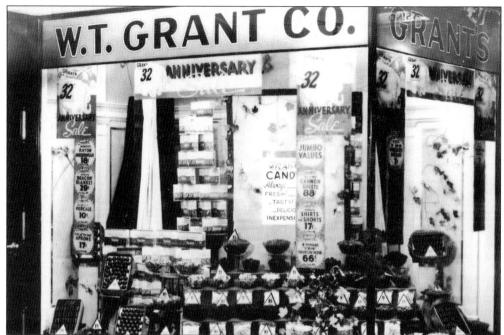

W. T. Grant Company. Founded in 1906, the W. T. Grant Company maintained stores throughout the United States. In 1938, the company's Crisfield store on Main Street celebrated the national chain's 32nd anniversary with deals including 17¢ shirts, 29¢ blankets, and 17¢ aprons.

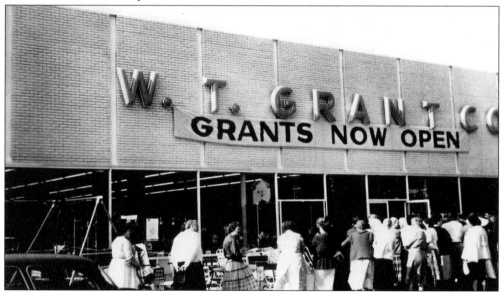

Grant's Reopening. In 1960, W. T. Grant Company moved its Crisfield store farther up Main Street, adjacent to today's city hall, and held a grand opening to celebrate. Following the store's closing, the Eagle's national variety chain store set up shop in the new building in 1977, followed by Dollar General several years after Eagle's closing in 1991. The City of Crisfield purchased the building in 2002 and demolished it in 2005 with plans to expand city hall.

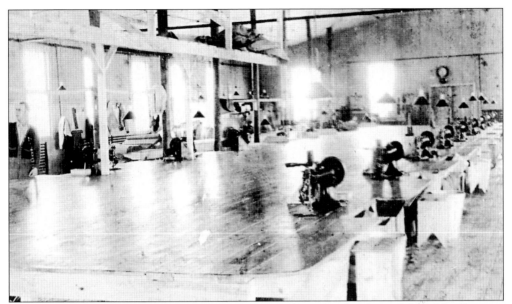

CRISFIELD CAP COMPANY. This 1940s image is believed to be that of the Miles Factory, opened on Locust Street in 1905 by E. Rosenfield and Company. Closed in 1931, it had reopened during World War II as the H. W. Truitt Tent Factory when this photograph was taken. In 1950, it was reorganized into the Crisfield Cap Company, which made hats for both soldiers and civilians as the last of the city's once-plentiful sewing factories.

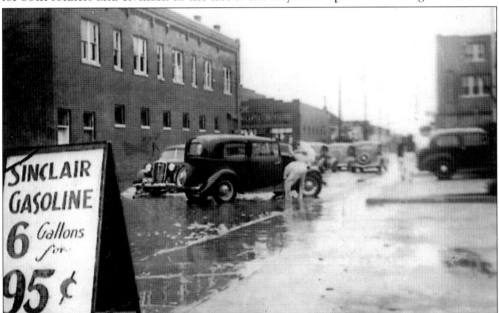

SINCLAIR GASOLINE. Gas was plentiful and cheap when this late 1930s photograph was taken from the Sinclair service station on Fourth Street, looking toward Main Street. Built by Reese Betts in 1929, the station changed owners, operators, and brands (including Sunoco and Citgo) several times before becoming a laundromat in the early 21st century. Other businesses in this view include, from left to right, the City Restaurant, A&P, and the New Arcade Theater.

ED THORNTON'S STORE. Located near the Arch Bridge at Jenkins Creek, Ed Thornton's Store is one of several that once served residents in that area. The store sold groceries, bottled soft drinks, and dry goods.

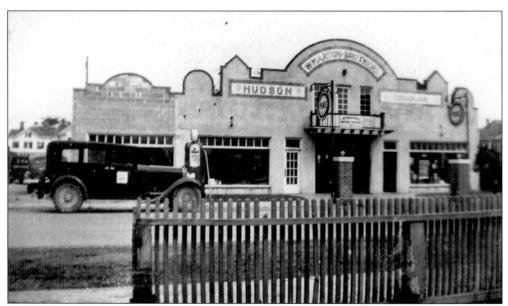

WHARTON BROTHERS. The Wharton Brothers dealt in two brands uncommon in today's market: Hudson automobiles and Pure Oil gasoline. Seen here around 1935, the building today serves a maintenance facility for the city of Crisfield.

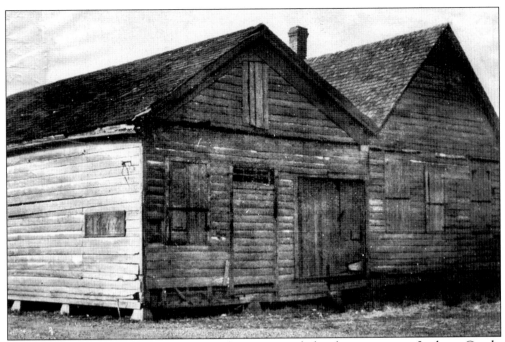

ALGIE STERLING'S STORE. Algie Sterling operated this business near Jenkins Creek, serving watermen and community members alike. The store sold groceries, dry goods, and other necessities of everyday life.

EASTERN SHORE PUBLIC SERVICE COMPANY. The focal point of this 1950s photograph is the man clearing brush in the open field, but the more interesting item is the Eastern Shore Public Service substation at the left. Built in the late 1940s, the substation belonged to the forerunner of today's Delmarva Power as the region's predominate electricity provider.

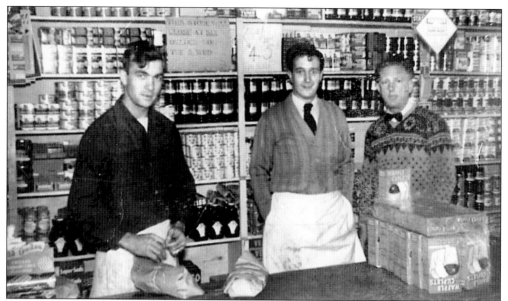

L. D. WARD GROCERY. Owned by Lorenzo "Gussie" Ward, right, this store was a Crisfield mainstay for years. The store was located on Crisfield Highway at the current site of Circle Inn Restaurant.

STAR BAKING COMPANY. Founded as the Tawes Baking Company on West Main Street in 1921, the renamed Star Baking Company remained a Crisfield fixture from 1945 until a fire destroyed the business in 1968. Part of the night shift for the bakery in the 1950s included, from left to right, (first row) Preston Scott, John D. Riggin, and Joe D. Scott; (second row) Richard Scott, Phyliss Byrd, Bill Taylor, Charles Ennis, and Lake Scott.

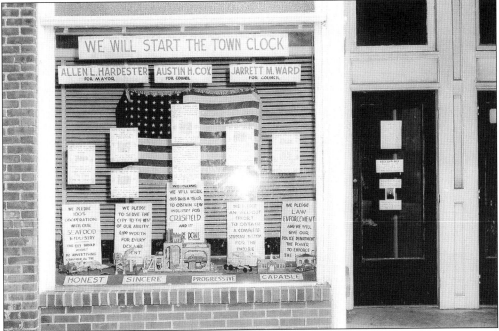

THE 1954 ELECTION. Crisfield mayoral candidate Allen Hardester and city council candidates Austin Cox and Jarrett Ward used this storefront to campaign for the 1954 city election on the platform of re-starting the town clock atop city hall. Hardester won the election.

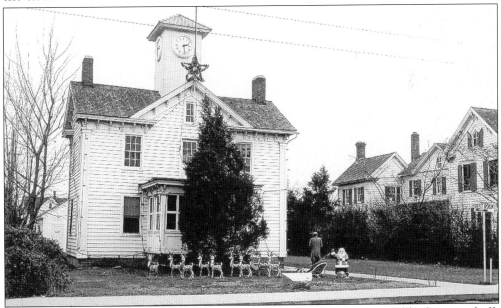

CITY HALL. The town clock mentioned above is seen here at Crisfield's first city hall. In 1931, the clock was dedicated in honor of Lorie Quinn Jr., a state politician and son of *Crisfield Times* founder Lorie Quinn Sr. The idea of a town clock was abandoned once city hall moved to a more modern brick building, which it currently inhabits on Main Street.

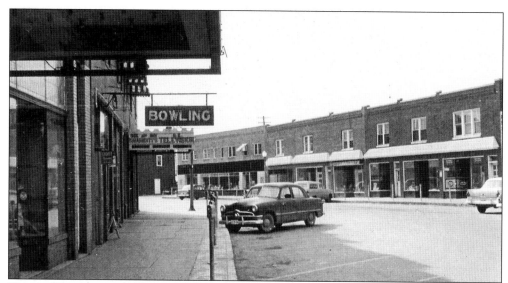

PLUCK DAUGHERTY'S POOLROOM. Located next to the New Arcade Theater, Charles Hubbard "Pluck" Daugherty's Poolroom was long a fabled place of recreation on Crisfield's Main Street. Also offering bowling alleys, as seen in this 1950s view, the business thrived for decades. A close look at the side of the building reveals an advertisement for Camel Cigarettes. A marquee similar to the one hanging over the New Arcade prompts customers to "See and buy Daugherty's G. E. Television."

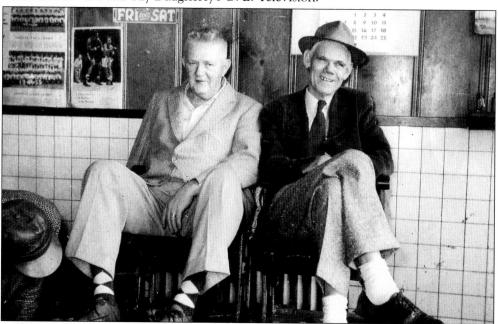

INSIDE PLUCK DAUGHERTY'S. Dido Tawes (left) and Arthur Record take a break at Henry Mills's shoeshine stand inside Pluck Daugherty's Poolroom on a lazy afternoon in February 1956. Photographs in the background include team shots of the Brooklyn Dodgers and New York Yankees, the World Series teams of 1955. Beside them is a movie poster for the 1954 film *Doctor in the House*, playing at the adjacent New Arcade Theater that Friday and Saturday.

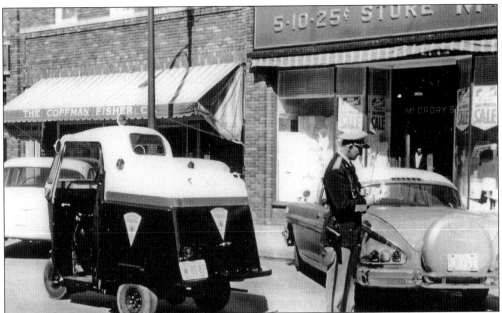

MCCRORY'S. Crisfield police officer Bob Evans writes a parking ticket for a car parked in front of McCrory's in this 1958 view. The Crisfield branch of the McCrory's chain opened on Main Street early in the second decade of the 20th century, serving the area until it closed in December 1995. Of particular note here is the 5-10-25 portion of the sign, which was removed in the 1960s when average prices of the merchandise inside increased beyond a quarter.

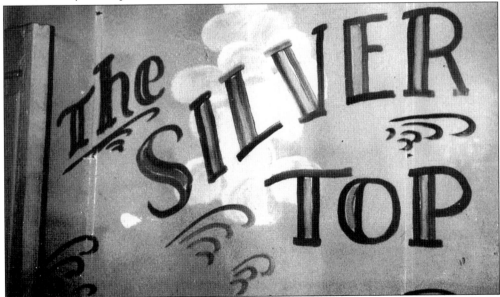

SILVER TOP. A favorite hangout for teenagers in Crisfield's Down Neck section, the Silver Top was named for its gleaming metal roof. The sign seen here, along with murals of winter scenes that adorned the soda fountain's walls, was painted by local artist and musician King Sterling. The business also featured unique tables made largely of metal pipes. The Silver Top closed in the mid-1960s.

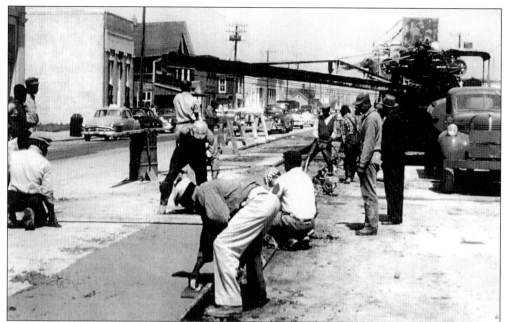

BUILDING THE DUAL HIGHWAY. In the early 1950s, John P. Tawes advocated for the construction of a dual highway through the main section of Crisfield to better the city's most traveled roads. Construction began in 1956, and the new dual highway opened the next year, connecting Maryland and Richardson Avenues and West Main Street. Informally known as "the Strip," the road was re-dedicated as the John P. Tawes Memorial Parkway in 2002. (Courtesy Scorchy Tawes.)

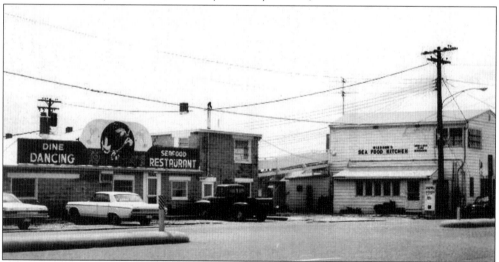

WINDSOR'S SEAFOOD KITCHEN. Opened by Homer and Elma Windsor in 1956, Windsor's Seafood Kitchen was a hallmark of Chesapeake Bay dining for years. In 1962, the restaurant moved to the buildings seen here at the site of the former Railway Express Agency office on West Main Street. In 1976, businessman James Dodson purchased the business and renamed it Captain's Galley Restaurant. The eatery and its famous crab cakes remained until New Year's Eve 2004, when it was closed in preparation for replacement by condominiums.

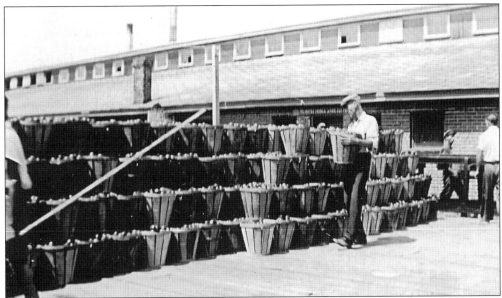

JOHN T. HANDY COMPANY. Founded in 1903, the John T. Handy Company is best known today as a worldwide soft crab exporter. However, from 1917 to 1961, the company also specialized in canning produce, including the tomatoes seen in this 1939 view. Most of the fruits and vegetables processed were bought in nearby Marion Station. When canning operations ceased, the former canning building was converted into Crisfield's first indoor crab shedding facility.

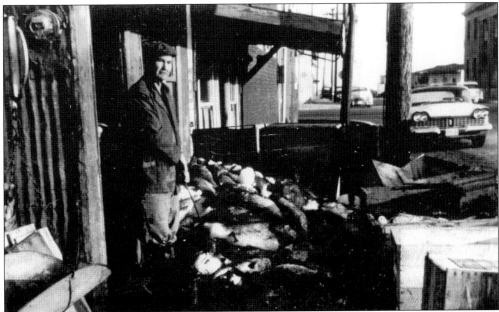

GREENIE'S MARKET. Greenleaf "Greenie" Hill, seen here in 1961, was perhaps Crisfield's most well-known fish merchant of the latter 20th century. Located just off West Main Street near where the Tangier Island Cruises office stands today, his fish market was a popular retail establishment and Hill himself one of Crisfield's most memorable characters. (Courtesy Scorchy Tawes.)

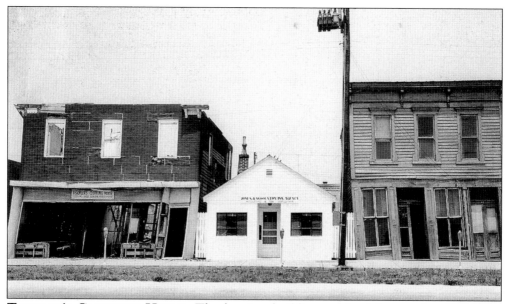

TISCHLER'S CLOTHING HOUSE. The leaning building to the left served as Tischler's Clothing House before this photograph was taken in 1958, while the one leaning to the right was the Wyatt Insurance Agency. The building in the center, housing the Jones and Woolston Insurance Agency, is the only one of the three in this image still standing on West Main Street. (Photograph by John McIntosh.)

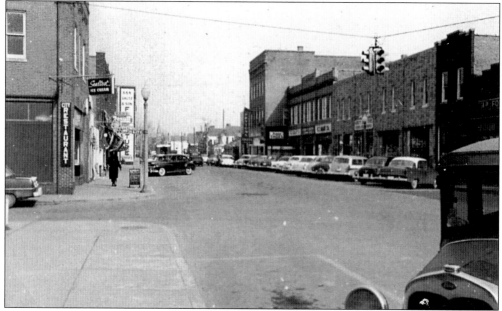

LOOKING DOWN MAIN STREET. Crisfield's uptown section was still booming when this 1960s photograph was taken at the corner of Fourth and Main Streets. Down the left side of Main Street, starting in the foreground, were Hilda's City Restaurant, Kent Pharmacy, McCrory's, Scher's, and S. and N. Saltz and Son Furniture. On the right side was the W. T. Grant Company, Frank P. Landon Clothing, Bata Shoes, and Peyton's Pharmacy.

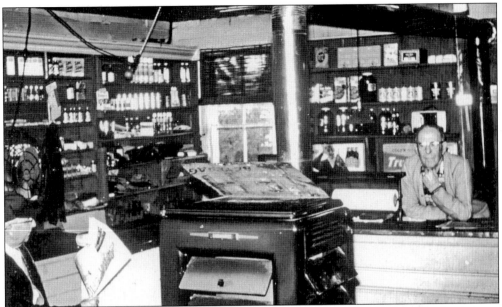

DUCKY'S STORE. Once as much of a Crisfield institution as Gordon's Confectionery, this country store opened at the corner of Lawsonia and Johnson Creek Roads in the early 1820s. George "Swiney" Lawson purchased it in 1888, operating it as Swiney's Store until Alonza "Ducky" Nelson, seen behind the counter in this 1960s view, took over the business in 1943. It then became Ducky's Store, a name it retained until its closing in 1977.

NOOK'S DRIVE-IN. Founded in 1960 by George "Nookie" Ward, Nook's Drive-In on Richardson Avenue was the spot for Crisfield's teenagers in the 1960s. Following several ownership changes, it became the E and N Restaurant in 1969. Remodeled after a 1972 fire, the drive-in portion of the eatery was removed in 1974. It was renamed Aunt Em's Restaurant, locally renowned for its fried chicken. The restaurant closed in 1998, and in 2005 it is the site of an Exxon convenience store.

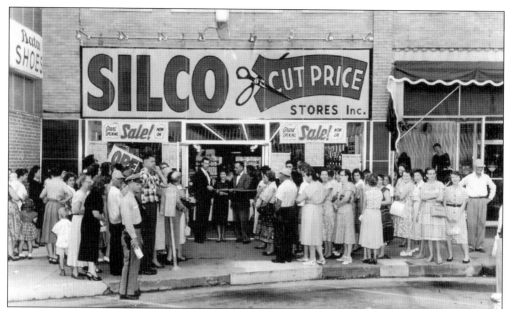

SILCO GRAND OPENING. Variety stores were on the rise in Crisfield when Silco's was introduced on Main Street in 1959. A revamped W. T. Grant Company moved in just down the street one year later, while McCrory's reigned supreme directly across from the new Silco store. (Photograph by John McIntosh, courtesy Mary Nelson.)

KOZY KORNER. Kozy Korner co-owners Edward and Roy Lewis, seen behind the counter, were all smiles when this photograph was taken on a busy Labor Day weekend 1966. Founded in the 1930s at the site of the former Mears Bakery on West Main Street, the Kozy Korner was for years a popular Crisfield mainstay. Moved from its original location to a larger building across the street in 1969, the restaurant remained an institution in the city until it burned in 1987. (Photograph by John McIntosh, courtesy Mary Nelson.)

Nine

RECREATION AND CELEBRATIONS

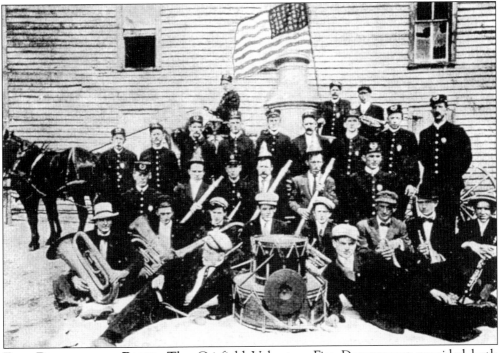

FIRE DEPARTMENT BAND. The Crisfield Volunteer Fire Department provided both safety and entertainment when this image was produced, c. 1905. Though not all the men in this photograph-turned-postcard have been identified, the picture does include long-ago Crisfielders B. Horace Ford, Jim Ailsworth, Tobe Stevenson, Rupert Somers, Will Poleyette, Sherman Dize, Lum Betts, George "Dickey" Davis, William "Leaguer" Holland, David Whittington, and George "Teagle" Wessells.

KING STERLING'S ORCHESTRA. Seen here in 1930, King Sterling's Orchestra was Crisfield's musical group of note well into the 1950s. The musicians in the top row are unknown. Pictured in front, from left to right are drummer Tom Marshall, King Sterling, unidentified, saxophonist Linwood Sterling, and two unidentified. (Courtesy Scorchy Tawes.)

BOY SCOUTS OF AMERICA. Crisfield's first Boy Scout troop posed for this 1912 photograph. Pictured here from left to right are (first row) McKinley Sterling, Orrie Lee Tawes, George Christy, Richard Jones, Kirk Maddrix, Bill Tilghman, Charlie Thornton, Vernon Webb, and Milton Collins; (second row) scoutmaster Bill Wedelin, Russell Wharton, Joseph Disharoon, Stanley Robins, Paul Purnell, Creston Collins, Mike Stokes, Gordon Adams, and scoutmaster Dr. C. E. Collins.

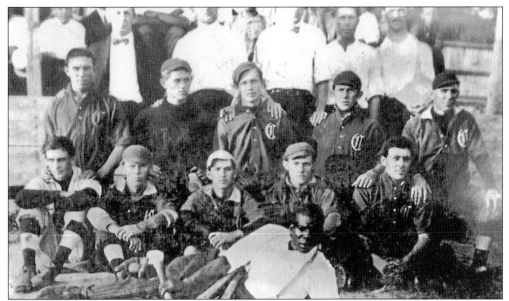

CRISFIELD BASEBALL TEAM. Seen here c. 1910, this was just one of many recreational baseball teams representing Crisfield during the early 20th century. Dr. C. E. Collins, one of Crisfield's most civic-minded leaders, is pictured at the top left.

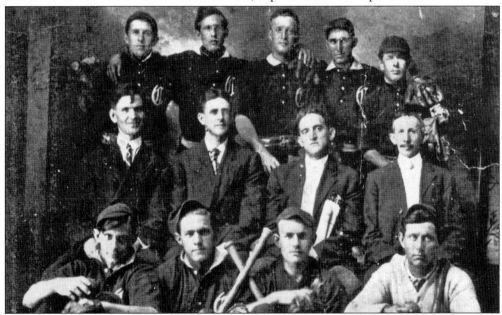

CRISFIELD REDS. The Crisfield Reds continued the city's baseball tradition into the 20th century. The team was organized in 1911, nearly 20 years after the city's first official team in 1892. The Reds played at Riggin Field, just off what is now Maryland Avenue. Pictured here from left to right are (first row) John Woodland, Raymond Woodland, W. Edwin "Ted" Riggin, and Clarence Howard; (second row) Brevoort Thawley, H. L. Loreman, Eugene Miles, and Dr. C. E. Collins, who helped bring the team together; (third row) Dyke Sterling, Lownie Tawes, Carl Hoffman, William Holland, and Charles Bradshaw.

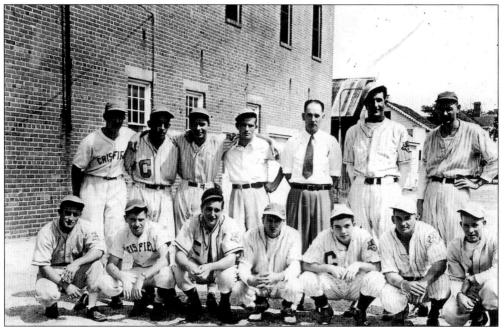

PHILADELPHIA OLD STOCK TEAM. Sponsored by the Philadelphia Old Stock Beer Company, this team, seen here in 1946, was one of many in the Crisfield area. Pictured from left to right are (first row) Chalky Goldsborough, Billy Brittingham, Titter Blades, Granville Tyler, Donald Chelton, Chris Owens, and Jimmy Ford; (second row) Frank Byrd, Biddie Tull, Joe Daniello, Ben Lawson, Eddie Cook, Charley Wilson, and Yarney Crockett.

DONKEY BASEBALL. For a city as passionate about baseball as Crisfield was throughout much of the 20th century, it should come as little surprise that its residents occasionally sought a little variety in the sport. In the 1950s, donkey baseball at the American Legion Field at Brick Kiln provided just that variety. The concept was simple: players adhered to the basic rules of baseball with the challenge of playing atop the aforementioned donkeys.

LITTLE LEAGUE ELKS. Established in 1952, the Crisfield Little League has maintained sponsorship from local civic organizations for more than half a century. Seen here is the 1963 team sponsored by Elks Lodge 1044. Pictured from left to right are (first row), unidentified, Corky Dize, Phillip Clayton, Ricky Sterling, unidentified, Lee Custis, and Russell Hicks; (second row) Jimmy Blades, Kenny Rice, Gary Hale, coach Donnie Drewer, Glen Nicholson, and Frank Rhodes.

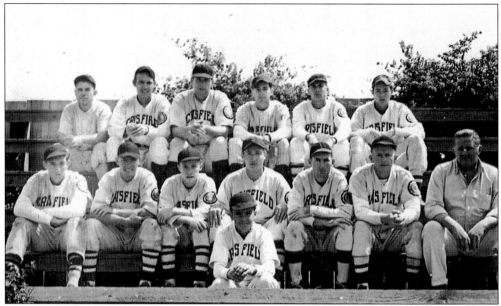

CRISFIELD VETS. This younger squad of the 1950s kept alive the name of the famed Crisfield Vets baseball team of the 1940s Central Shore League. Pictured from left to right are (first row) Bill Lankford, Jack Brittingham, Jimmy Ford, Raymond Morgan, Harold Lawson, Royce Dize, Jack Milbourne, and manager Dido Tawes; (second row) Gene Stant, George Crockett, Noah Dize, Charles Lowe, Ditty Nelson, and Calvin "Cabby" Dize.

CRISFIELD COUNTRY CLUB. Two duffers practice their putting at the Crisfield Country Club in this 1955 image. No longer open to the public, the country club property remains today. Its clubhouse sometimes is still used for private parties. Decades after the country club closed, Somerset County saw new public greens with the opening of Great Hope Golf Course in nearby Westover in 1995.

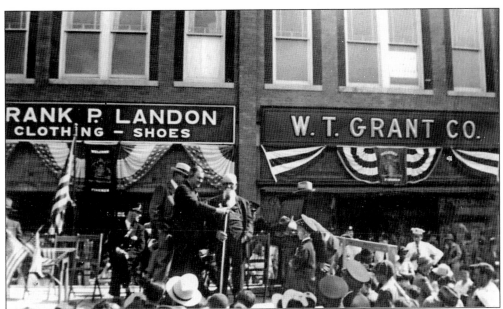

DELMARVA FIREMEN'S CONVENTION. Crisfield played host to the Delmarva Fireman's Association convention in 1939, welcoming dozens of volunteer fire companies from throughout Delaware and the Eastern Shore of Maryland and Virginia. Speakers for the festivities included association president Fred Brown and Maryland comptroller J. Millard Tawes, a Crisfield native whose first statewide office had been as president of the association in 1936.

FRANK P. LANDON CLOTHING. Perhaps at no other time in Crisfield's history have so many fire engines gathered on Main Street as during that convention. Situated in front of the Frank P. Landon clothing store, the reviewing stand for the grand parade provided quite a view for association officials. A banner hanging under the Landon sign, as well as throughout much of the rest of the city, stated simply, "Welcome firemen."

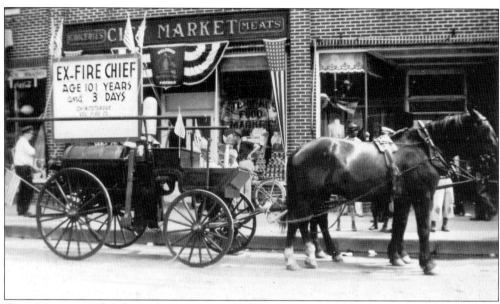

CITY MARKET. Thanks to the convention, this rare Main Street photograph of Crisfield's City Market, also known as Sterling's Food Market, exists today. In front, a horse-drawn fire apparatus celebrated the Delmarva Peninsula's oldest fireman, from Chincoteague, Virginia. Note the bunting in the center of the photograph, which boasts just 48 stars two decades before Alaska and Hawaii gained statehood in 1959.

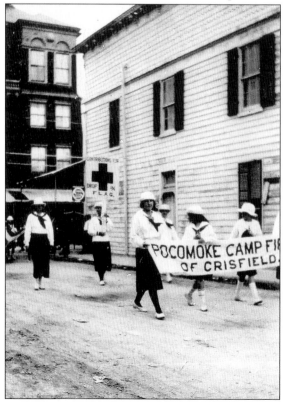

RED CROSS PARADE. Red Cross nurses from the Delmarva Peninsula gathered in Crisfield for this parade and convention in the early 1920s. Pictured are the Pocomoke Campfire Girls of Crisfield, marching in support of the Red Cross. The troop was named not for the nearby city of Pocomoke, but for the Native American tribe that once inhabited the region. (Courtesy Skip Marshall.)

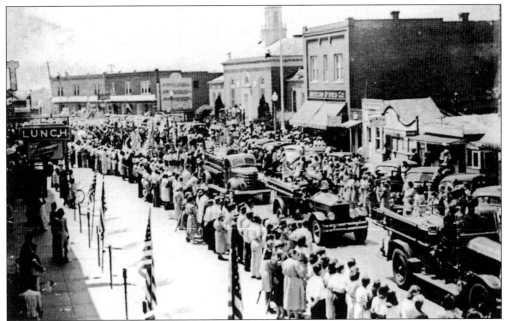

V. E. Day Parade. Crisfield joined the rest of the nation in celebrating Victory in Europe Day during World War II with a grand Main Street parade. Businesses in the background include the post office, the American Store, City Taxi, Byrd's Luncheonette, and Kent Pharmacy. The billboard on the Whittington building in the background advertises DuPont paints.

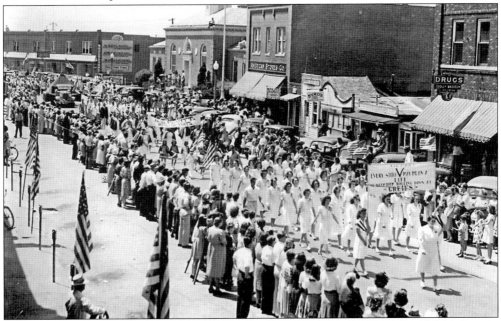

Greif Clothing Company Employees. Employees of Crisfield's L. Greif shirt factory joined the V. E. Day celebration, carrying a banner reading "Victory. Every shirt may save a life. We keep rolling down at Greif's." Behind Greif's entry is another marching unit, comprised of employees from the H. W. Truitt Tent Factory on Locust Street.

KIDS DAY PARADE. The Kiwanis Club of Crisfield has celebrated Kids Day each fall for more than half a century. Traditionally featuring a costume parade shortly before Halloween, this 1950s installment included this junior waterman, complete with his crab pot and oyster tongs. In the 1950s and 1960s, Kids Day festivities also featured bicycle races and a free cartoon matinee at the New Arcade Theater.

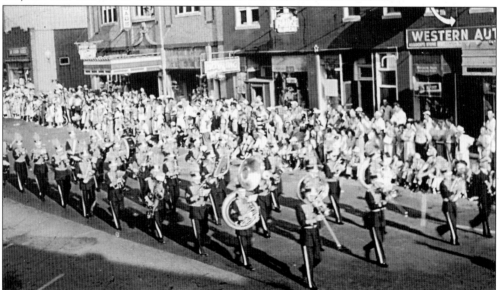

AMERICAN LEGION BAND. Led by King Sterling, the Crisfield Stanley Cochrane Post 16 American Legion Band once was the city's own, performing at celebrations and festivals throughout the area. The band is seen here on Main Street during the first National Hard Crab Derby parade in 1950. Members included John Handy, Eugene "Squeaky" Mills, and Tanky Hickman. The band's honor guard included Robert Bradshaw, Tom Blades Jr., and Charles Sterling.

NATIONAL HARD CRAB DERBY. Celebrated internationally as one of the world's most unique festivals, the National Hard Crab Derby has been a mainstay of Crisfield since 1948. Prompted by a 1947 editorial in the *Crisfield Times*, the first crab races took place in front of the post office on Main Street. Pictured at that inaugural event in front from left to right are Rob Wharton; Wilbert Coulborne with the first winning crab, Scobie; and Naugie Adams. Originally the crabs raced from the middle of a chalk circle, first drawn on the street then later at Somers Field and the downtown steamboat wharf. A plywood race board later gave the crabs more leverage and served as the precursor of today's Crab Cake Track, a slotted race board used since the 1970s. (Photograph by Dick Moore, courtesy Scorchy Tawes.)

SWEET SHOP. Located next to the New Arcade Theater at Fourth and Main Streets, the Sweet Shop was one of Crisfield's most popular hangouts before and after the movies (or any time the desire struck for an ice cream soda). Seen here one Labor Day weekend in the early 1950s, the business was closed from 2:00 to 4:00 p.m. to allow its patrons and employees to enjoy one of the first National Hard Crab Derby parades.

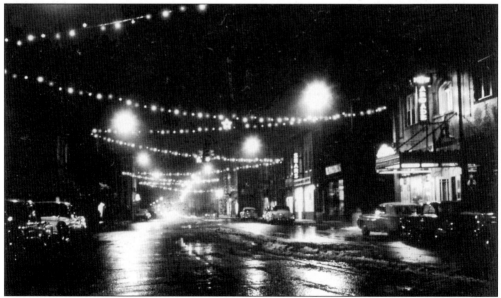

CHRISTMAS IN CRISFIELD. Signs for the New Arcade Theater and Sears gleamed on Main Street, as did hundreds of colored Christmas lights strung overhead when this photograph was taken around 1960. Today the Crisfield Lions Club continues to light the street for Christmas each year.

Ten

FAMOUS FACES

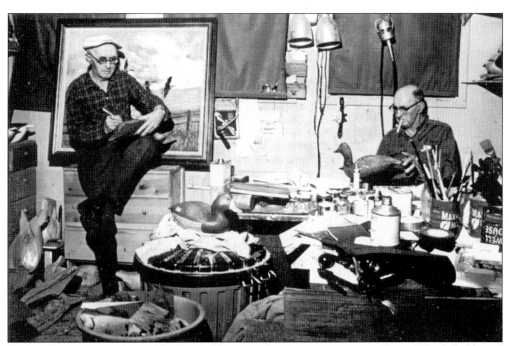

WARD BROTHERS. Arguably Crisfield's most famous native sons, Steve Ward (left) and his brother, Lem, carved some of the most notable decoys ever created. In 1948, they won the National Decoy Contest in New York City, drawing worldwide attention to their art for the rest of their lives. This 1970 image shows the artists with some of their final works before being sidelined by health problems. Steve passed away in 1976, followed by Lem in 1984. (Courtesy Scorchy Tawes.)

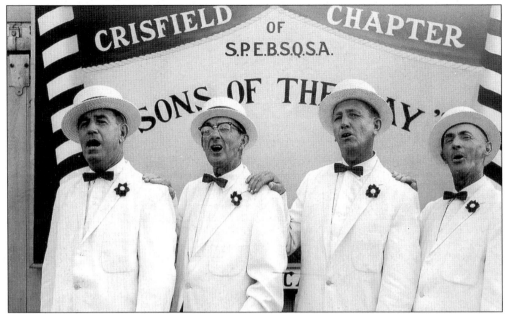

THE '29ERS. Organized in Crisfield in 1927, the '29ers were the oldest group in the Society for the Preservation and Encouragement of Barber Shop Quartet Singing in America (S.P.E.B.S.Q.S.A.) when this publicity photograph was taken in 1963. The New Arcade Theater hosted the regional barbershop quartet show "Festival of Harmony" that April. Pictured here from left to right are tenor Lawrence Tyler, lead Lem Ward, baritone Harlan Tyler, and bass Steve Ward. (Courtesy Mary Nelson.)

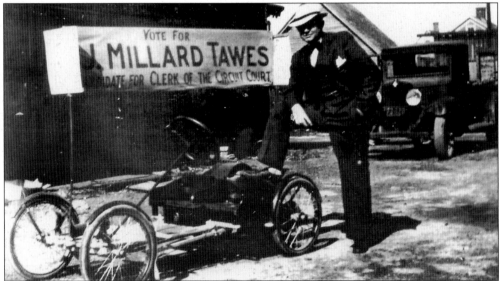

J. MILLARD TAWES. Born in Crisfield on April 8, 1894, J. Millard Tawes became one of the nation's most noted political leaders in the 1960s as the first Southern governor to speak out in favor of desegregation. Decades before, however, he began his political career in Somerset County as a 1930 candidate for clerk of the circuit court. The go-cart used in his campaign later was outfitted with a bread loaf–shaped sign to advertise his family's downtown Crisfield bakery.

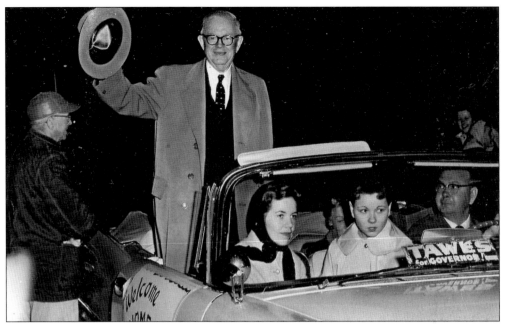

VICTORY PARADE. Elected Maryland's 59th governor in a landslide decision, Tawes returned home to a victory celebration in November 1958. In the front seat from left to right are unidentified, Sylvia Drewer, and Carlton Drewer. (Courtesy Mary Elizabeth Drewer.)

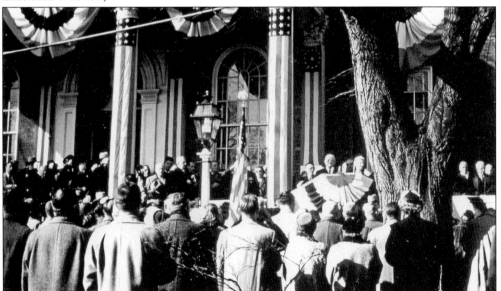

GUBERNATORIAL INAUGURATION. Crisfielders flocked to the State House in Annapolis for Tawes's gubernatorial inauguration in January 1959. After two terms as governor, he continued to make state history as the first secretary of the Maryland Department of Natural Resources (DNR), a position to which he was appointed in 1969. Tawes passed away June 25, 1979. Today his legacy includes the J. Millard Tawes Museum in Crisfield and the annual J. Millard Tawes Crab and Clam Bake, one of the state's most notable annual political affairs.

PRESIDENTIAL VISIT. In 1934, the U.S. Commerce Department boat *Sequoia* delivered Pres. Franklin D. Roosevelt to Crisfield en route to a visit in nearby Pocomoke City. Before heading to the Worcester County municipality, he made a stop in Crisfield for a brief tour of Makepeace. Four years later, he returned to Crisfield aboard the presidential yacht *Potomac*, seen here at the city's steamboat wharf.

CROSSING THE JERSEY ISLAND DRAWBRIDGE. On Labor Day 1938, Roosevelt and his entourage crossed the Jersey Island Drawbridge to reach their destination during the president's "official" visit to Crisfield in an unsuccessful attempt to rally support against political rival Sen. Millard E. Tydings. The speed limit on the bridge was five miles per hour.

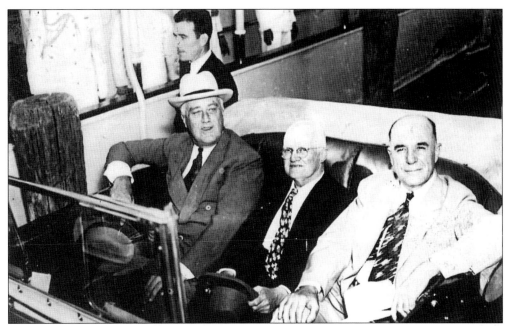

PRESIDENT ROOSEVELT. Democratic senatorial candidate David J. Lewis, center, and Congressman T. Alan Goldsborough, right, joined the president as he made his way down Main Street. Crisfield mayor William Ward, a Republican, refused to meet the president and closed the curtains at his business in protest of Roosevelt's visit.

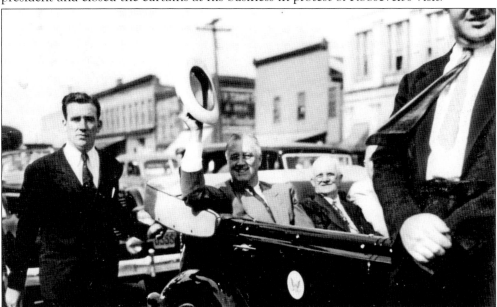

WAVING ON MAIN STREET. Roosevelt waves to crowds on Main Street from his Packard convertible touring car. After returning to the steamboat wharf, Roosevelt boarded a train for a whistle-stop tour of the Eastern Shore. In Salisbury that afternoon, he gave a nationally broadcast speech in which he referenced a woman waving an American flag just outside Crisfield. That woman later was identified as Hopewell resident Sena Landon, who offered the flag salute as the president passed her house.

DR. SARAH PEYTON. One of the most respected doctors in Crisfield's history, Dr. Sarah Peyton received her medical training at Johns Hopkins University at the encouragement of her father, pharmacist William Peyton. Returning as Crisfield's first female doctor, she not only treated physical ailments but was a proponent of mental health throughout the area. In 1964, the Somerset County Board of Education named the Sarah M. Peyton School for children with mental disabilities in her honor. (Courtesy Scorchy Tawes.)

GROVER ADAMS. Crisfield's bicycle-riding fireman, Grover Adams, outfitted his bike with flashing lights and a hand-cranked siren to warn motorists to clear the road when he was on his way to the fire hall on emergency calls. Adams joined the Crisfield Volunteer Fire Department in 1919 and was still serving when he died while fighting a fire at the former school on Collins Street in 1971.